IMAGES
of America

CORRALES

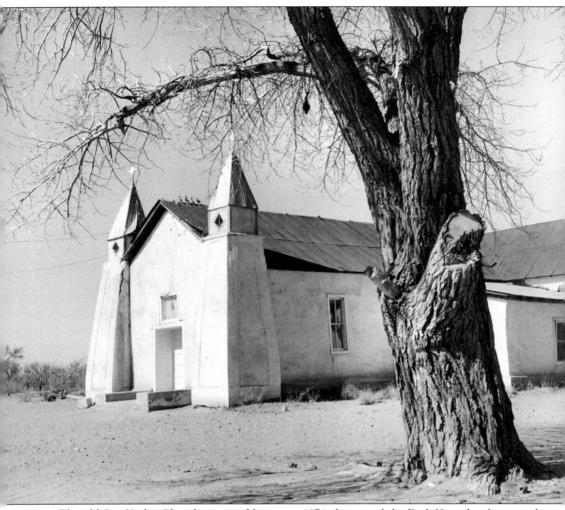

The old San Ysidro Church, pictured here in a 1974 photograph by Dick Kent, has become the symbol of Corrales and is featured on the official village seal. The first mayor of Corrales, Barbara Tenorio Christianson Twining, wrote that it is "the single point of community pride that strikes a responsive chord in the hearts of all. For the village and all of its citizens it provides the symbol of a common heritage." (Corrales Historical Society Archives.)

ON THE COVER: A traditional Christmas celebration was the nativity play based on the story of the shepherds coming to worship Jesus in Bethlehem. This Christmas 1910 photograph was taken in front of the old schoolhouse in Corrales and is titled "Pastores de la Adoración, hecha por José de Jesus Lopez." It is one of the oldest photographs in the Corrales Historical Society Archives. (Georgia Silva Catasca.)

IMAGES of America
CORRALES

Mary P. Davis and the
Corrales Historical Society

Copyright © 2010 by Mary P. Davis and the Corrales Historical Society
ISBN 978-0-7385-8453-9

Published by Arcadia Publishing
Charleston, South Carolina

Printed in the United States of America

Library of Congress Control Number: 2009938749

For all general information contact Arcadia Publishing at:
Telephone 843-853-2070
Fax 843-853-0044
E-mail sales@arcadiapublishing.com
For customer service and orders:
Toll-Free 1-888-313-2665

Visit us on the Internet at www.arcadiapublishing.com

To my husband, Paul, who designed and built our Corrales home.

Contents

Acknowledgments 6

Introduction 7

1. The Setting 9
2. Families 19
3. Farm Life 53
4. The Old Church 67
5. Gathering Places 83
6. Growing Up in Corrales 97
7. Moving On 105
8. After the War 113

Acknowledgments

I owe the greatest debt to the many people and institutions who shared photographs and memories with me—their names can be found throughout this book. Families welcomed me into their homes, often sharing coffee or iced tea as well as family history and stories, and were patient with my questions and generous with their time.

Alice Glover, the indefatigable president of the Corrales Historical Society (CHS), introduced me to several Corrales families whose contributions greatly enriched this story of Corrales. CHS board member and photographer Ginger Foote gamely accompanied me into homes in Albuquerque, Corrales, and Bernalillo to photograph portraits (often behind curved glass) of revered family members. Another board member, Cliff Pedroncelli, joined us on several visits, and his amazing memory and stories encouraged others to share theirs.

The archives committee of the historical society has spent many hours sorting and filing the photographs, newspaper articles, organizational ephemera, manuscripts, genealogies, interview notes, and copies of official papers that have been given to the society over the years. These archives were invaluable, as were the society's computer and scanner, made possible by a grant from Intel obtained by former CHS president Jerry Goss. Photographs from the society's archives are credited with the line "CHS Archives." All photographs by Harvey Caplin are copyrighted by the Caplin estate and are used by permission. Inquiries regarding reproduction should be directed to Abbie Caplin at www.western-collectibles.com.

Ben Blackwell illuminated the workings of the digital gadgets that facilitated the process of transferring photographs from the CHS computer to mine, saving me much frustration. Archeologist Mike Marshall enlightened me as to Corrales' long prehistory during an enjoyable morning spent visiting local archeological sites; he also reviewed the paragraphs on Corrales before written records. Historian John Grassham read through the introduction and the chapters, and suggested needed changes. Arcadia editor Jared Jackson gently nudged me when I needed it.

Errors in dates, names, and stories are all mine. Unfortunately there are more stories and more families that have not been included here. The historical society will keep on collecting and interviewing, but I doubt we will ever be satisfied that we have the whole story.

INTRODUCTION

The village of Corrales lies 10 miles north of Old Town Albuquerque on the floodplain of the Rio Grande. To the west stretch miles of what were once grassy mesas and to the east, more grasslands rise across the river to the granite bulwark of the Sandia Mountains. This valley of fertile fields flanked by grassy mesas and protected by a high, forested mountain range has attracted settlement for over a millennium.

Archeologists have found pit houses and hamlet villages that are more than 1,000 years old throughout the valley, some identified in north Corrales and others just south of the village. Population in the valley increased dramatically after 1200 CE, and two large pueblos and some scattered smaller pueblos have been found in or near Corrales. Most of these settlements appear to have been abandoned before or during Coronado's 1540 expedition into New Mexico, although evidence of occupation during the 1600s has been found at part of one of the large pueblo sites. Both Santa Ana Pueblo and Sandia Pueblo state that their ancestors lived and/or farmed in the Corrales area.

Coronado and his men probably traveled through the Corrales valley since archeologists have found 16th-century Spanish camps just north of modern-day Corrales. After Juan de Oñate colonized the province in the early 1600s, men who had come with him settled along the Rio Grande; historical records attest that one of these settlements was in the present Bernalillo area. No official records exist of 17th-century Spanish settlements in the Corrales valley. Sandia and Santa Ana Pueblos were inhabited at this time, and there was also a large pueblo called Alameda south of Sandia Pueblo.

Alameda Pueblo was abandoned in 1709, and the following year the Alameda land grant was given to Francisco Montes Vigil in return for his service in the Reconquest. Vigil could not settle the land as required by Spanish law, and in return for a loan of $200 and "many other kindnesses and services," Vigil transferred the grant in 1712 to Capitan Juan Gonzales Bas, who lived in nearby Bernalillo and was soon to be named *alcalde* (or mayor) of the new villa of Albuquerque. When the grant was first given, its boundaries were the Rio Grande on the east (2 to 3 miles farther east than its modern bed), an old pueblo on the north, the *ceja* (ridge) above the Rio Puerco on the west, and the "hill of Luis Garcia" on the south. The name Corrales has been attributed to either or both of two historic settlement patterns: it could have been the site of corrals for land owners who ran their stock on the high grassy plains west of the river, or it was the site of corrals for the horses used by local militia to fend off Native American raids, since most of the raiders came from the west or northwest.

Fray Francisco Dominguez wrote in his 1776 report on the province that the middle Rio Grande valley was "a settlement of ranchos on the meadows of the said river . . . They are watered by the said river through very wide, deep irrigation ditches, so much so that there are little beam bridges to cross them. The crops taken from them at harvest time are many, good, and everything sown in them bears fruit . . . Not all those who have grapes make wine, but some do." He recorded

Corrales as two settlements: Upper Corrales, opposite the pueblo of Sandia with 10 families with 42 persons, and Lower Corrales (probably located south of today's intersection of Corrales Road and Route 528), with 26 families with 160 persons.

The Gonzales family appears to have settled on both sides of the river, since local lore puts an old Gonzales home in what was Lower Corrales, and Dominguez records a chapel in Alameda maintained by one Gaspar Gonzales. It is believed that the central part of Corrales was sold sometime in the 18th century to Salvador Martinez, and the northern reaches (probably Upper Corrales) was settled by the Montoya family. Since Spanish families divided land among all heirs, and each piece of land had to have access to water, the land was divided into long lots stretching between the ditch or the river and the west boundary of the grant. Over the centuries some of these long lots narrowed until they were only 25 to 30 feet wide. Aerial photographs of Corrales show this long lot pattern.

Soon after Mexico gained its independence from Spain in 1821, Mexico opened its northern provinces to Americans, and the Santa Fe Trail was blazed between St. Louis, Missouri, and Santa Fe, New Mexico. The trickle of newcomers on the trail increased to a steady flow after the United States acquired New Mexico in the Mexican American War in the 1840s. The flow became a flood when the railroad reached the territory in 1879. Among the immigrants were French, Italian, and German farmers, as well as some Midwesterners who had heard of the fertile lands along the Rio Grande, dubbed by local boosters as "the Nile of the Southwest."

By the 1940s, when Albuquerque was discovered by the outside world, Corrales was discovered right along with it. Long isolated on the west side of the river with only a narrow bridge connection to the Albuquerque area, Corrales gradually became less isolated with the building of a new road connection on the west side of the river and construction of a new bridge in 1957. By the 1960s, Corrales had thriving community organizations that raised money by hosting balls and holding historic house tours.

In 1960, an Eastern development company platted a new town named Rio Rancho just west of Corrales. With the possibility of annexation by Rio Rancho or Albuquerque, Corrales residents voted to incorporate in 1971. They elected a mayor, a judge, and a village council, and created a comprehensive plan to prepare the small village for its inevitable growth.

And it has grown. The once-empty sand hills on the west side of the village and the valley itself are now mostly covered with 1- or 2-acre home sites, though some fields and orchards still stand. The population in 2000 was 7,334, and Corrales is soon expected to reach 10,000.

Remnants of the old rural ways remain. The ditches still run with water, and there are a few large farms left, although only one truly sustains its owners. Many front yards have corrals for horses, sheep, goats, or cattle. Residents create large and abundant vegetable gardens and sell their produce at a thriving growers' market. More roads are paved, but homes remain on septic systems, and everyone has a water well.

No longer isolated but now an oasis in an urban desert, Corrales fights to keep its independence and its way of life. The village employs essential positions like an administrator, a planner, a parks and recreation director, a head librarian, police and firemen, but volunteers run almost everything else. Corrales strives to hold onto the strength and beauty of its history, and to meet the demands of change with the wisdom to know what to preserve and what should be allowed to progress.

One

THE SETTING

Corrales' long history has been shaped by its geography. A westward shift in the bed of the Rio Grande sometime in the 18th century divided the settlement from its parent community of Alameda. Corrales was isolated on the west side of the river, its fertile farm lands nestled between an eastward curve of the river and the edge of the vast plains stretching westward to the Rio Puerco. The settlement was an easy target for Navajo, Apache, and Comanche raiders sweeping across the plains from the northwest.

The nearest community west of the river to the south was Atrisco, some 10 to 12 miles away; a similar distance to the north were the pueblo of Santa Ana and the old Spanish town of Bernalillo. The Rio Grande, which lay between Corrales and its two nearest neighbors on the east—Alameda and Sandia Pueblo—could sometimes be crossed on foot, but until a bridge was built in the late 1800s, the choice was either to wade or ferry across.

The river provided Corrales many of its needs. Most important was water for irrigation. A rude dam was built annually at the north end that channeled the river into an *acequia* (irrigation ditch) probably dug sometime in the mid-18th century. Along its banks the river nourished a bosque, the cottonwood forest that provided fuel and building materials, although the *vigas* (long, straight log beams) were brought from the mountains. There were swamps near the river, and from these clayey areas residents dug the mud for adobe bricks or cut *terrones*, root-filled sod blocks, with which to build their homes.

West of the floodplain stood high sand hills, remnants of the edge of an ancient riverbed. Beyond them stretched open grasslands that mirrored the mesa east of the river belonging to the pueblo of Sandia. Today the western mesa is an expanding city, but Sandia's lands remain open, broken only at their south end by Sandia Casino, which rises like Shiprock above the mesa. Towering above the Pueblo lands are the Sandia Mountains that fill Corrales' eastern prospect.

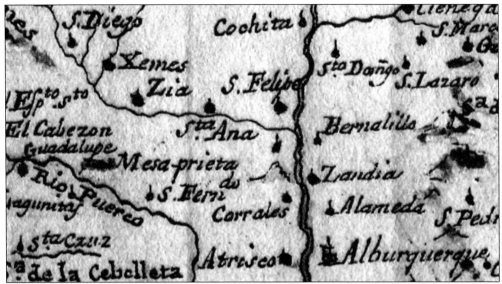

This 1778 map by Bernardo de Miera y Pacheco, mapmaker for the 1776 Dominguez-Escalante Expedition, clearly shows Corrales on the west side of the Rio Grande. The Rio Puerco does not bend sharply west, as Miera shows it, but roughly parallels the Rio Grande. The Alameda grant stretched from the town of Alameda to the Puerco. (Mapping and Geographic Information Center [MAGIC], University of New Mexico.)

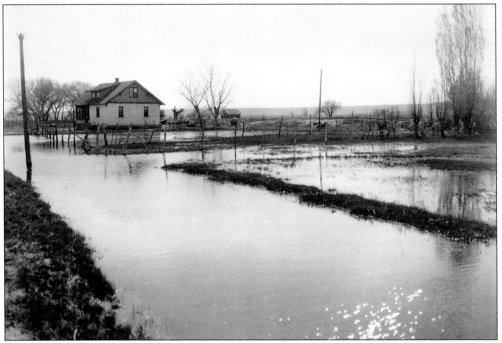

The Rio Grande provided the water that was the lifeblood of Corrales, but it could also destroy. The October 1904 flood claimed many homes in the village and ruined acres of crops. Flooding was eventually controlled by the dams and levees of the Middle Rio Grande Conservancy District (MRGCD), which took this 1931 photograph of standing water on the Francisco Garcia property in Corrales. (MRGCD.)

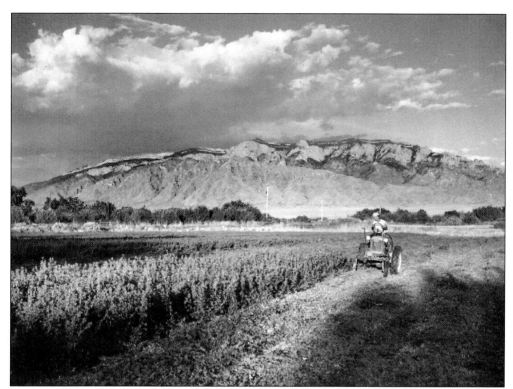
Since no photographs exist of Corrales before the late 1800s, and few show its topography, more recent images must be used to convey the early landscape. This 1950s photograph by Dick Kent shows the fertile floodplain stretching toward the bosque along the Rio Grande with the Sandias looming in the east. (Kent family.)

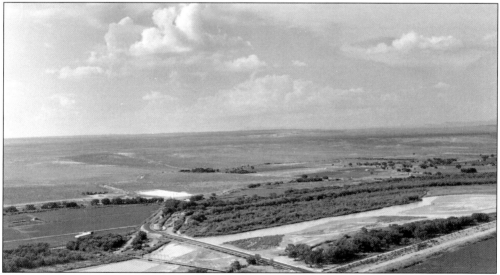
This 1956 aerial view, taken by Dick Kent, of the Corrales Bridge under construction shows the vast grassy plains that stretched westward from the edge of the Rio Grande floodplain to the ridge of the Rio Puerco. Here the early citizens of Corrales grazed their sheep and cattle, and Navajo raiders swept down across its empty acres. (CHS Archives.)

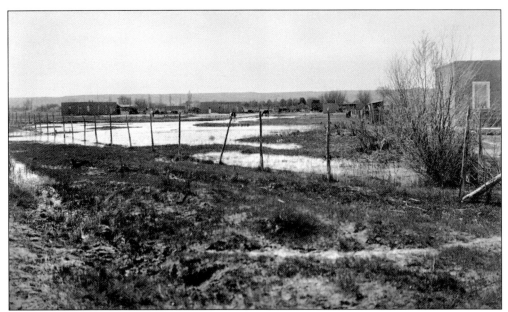

The western sand hills that edged the Corrales valley are just visible in the distance in this 1931 photograph. Although to a modern eye they seem an insignificant barrier, for a society with little metal and no machinery, these 100- to 200-foot-high hills appeared to be an unalterable edge to their settlement. The ponds shown here had resulted from rising groundwater as the riverbed silted up over the centuries. (MRGCD.)

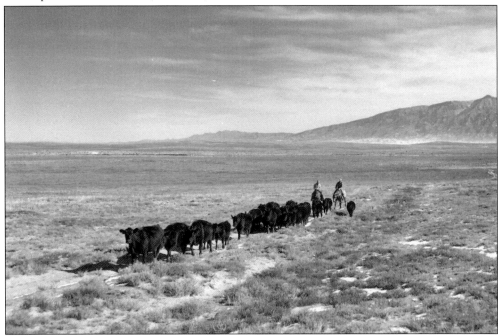

On the grant lands west of Corrales, cattle are herded on the Koontz Ranch in the 1950s in this Harvey Caplin photograph. A. B. MacMillan acquired the land in 1921 and sold it to the Thompsons in 1923. In the late 1950s, it was developed as Rio Rancho. (Koontz family and the Harvey Caplin estate.)

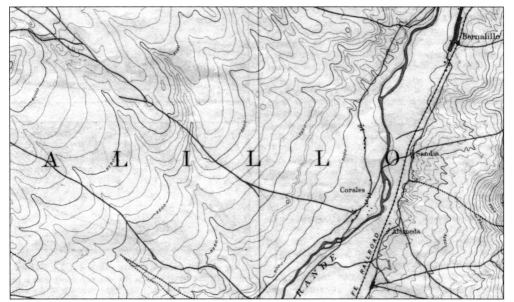

Two river crossings at Corrales—one to Sandia Pueblo and one angling southeast to Albuquerque's North Valley—are shown on this 1893 U.S. Geological Survey (USGS) map. The latter crossing was probably a bridge since a 1905 newspaper article notes that one was destroyed in the 1904 flood. Old-timers remember crossing to Sandia on a small ferry. (MAGIC, University of New Mexico.)

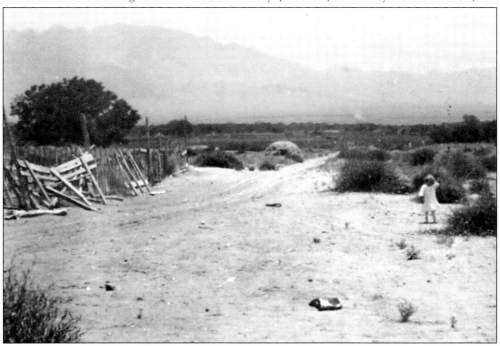

In the 1930s, a child wanders across her parents' land at the western edge of the floodplain just below the main irrigation canal. Land in this area, several feet higher than that by the river, did not receive irrigation water until the mid-1930s when the Conservancy District, formed in 1925 to improve irrigation in the Rio Grande valley, dug a new ditch just below the sand hills. (Rosie Targhetta Armijo.)

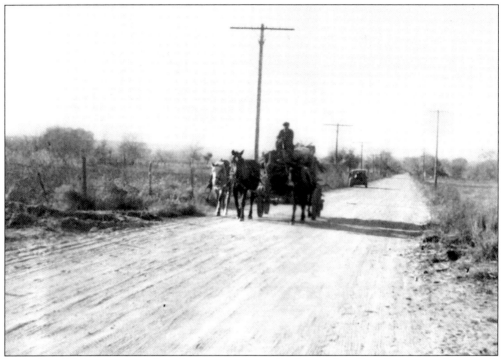

In the late 1930s, a wagon and a solitary car traverse the dirt road to Corrales in this photograph by Paul A. F. Walter Jr. The road connected the main highway at North Fourth Street to the bridge across the Rio Grande, the only one between downtown Albuquerque and Bernalillo. The sparsely traveled, two-lane Corrales Road is now the four-lane Alameda Boulevard. (Stanford University Library.)

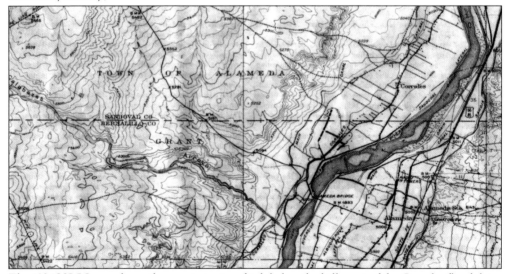

The 1934 USGS map shows the new irrigation ditch below the hills west of the Corrales floodplain. The hills are bisected at several places by roads leading to the Rio Puerco and by arroyos that could carry floodwater into the valley. Arroyo flood control was not addressed until the 1960s, when Corrales residents Harvey and Annette Jones founded the Corrales Watershed Board. (MAGIC, University of New Mexico.)

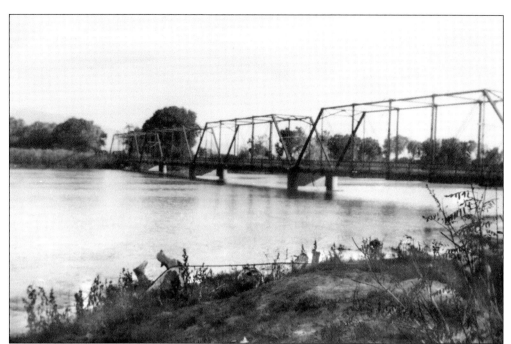

The narrow, steel truss bridge over the Rio Grande that connected Corrales to Albuquerque, shown in the photograph above by Paul A. F. Walter Jr., was built in 1912. This bridge took years to complete after Sandoval County discovered that the old bridge destroyed in the 1904 flood was in Bernalillo County and they refused to build the new one. In the 1946 photograph at right, Fita Armijo Leal poses on the railing of the old bridge above the wooden planks that swayed and rattled when anyone crossed the structure. The bridge was so narrow that only one car at a time could use it unless both cars carefully straddled the planks. Old-timers remember crossing the bridge early in the morning in a truck or wagon taking produce into Albuquerque to sell at the stores on First Street. (Above, Stanford University Library; right, Dianne Leal)

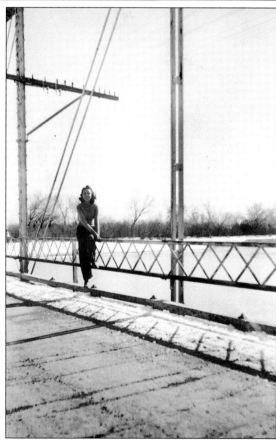

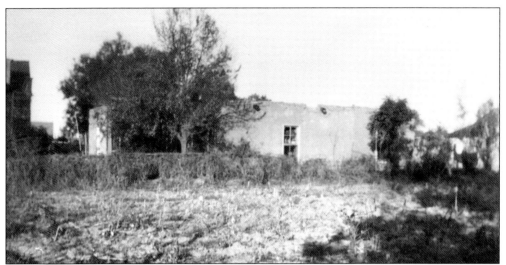

All but a few of the old houses in Corrales were built of adobe bricks or with *terrones* (sod blocks cut from swamps) and covered with mud plaster. This house, photographed in the mid-1930s by Paul A. F. Walter Jr., was probably one-room-wide and perhaps consisted of three rooms. There was no indoor plumbing or heating. (Stanford University Library.)

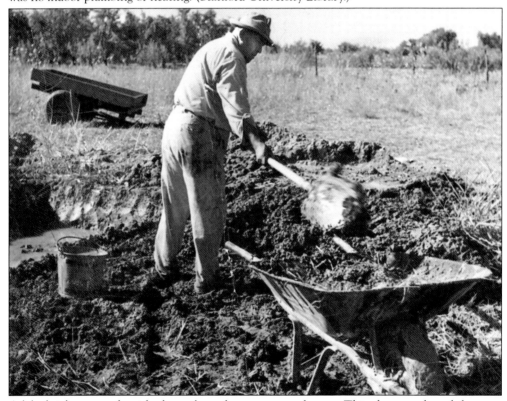

Adobe bricks are made with clay soil, sand, cut straw, and water. This photograph and those on the next page were shot by cinematographer Ken Marthey in the late 1940s. The adobe bricks were being made with soil dug on site for the home he built in Corrales. He had hoped to make a swimming pool in the hole dug for the soil but didn't get around to it. (Kenneth Marthey.)

Once the adobe mixture is thoroughly worked together and is stiff enough to be handled, it is shoveled into dampened wooden forms—usually rectangles roughly 4-by-10-by-14 inches. Then it is tamped and the excess mud scraped off. If the mud mixture is workable enough to lift the form, the form is removed, washed, and then refilled. (Kenneth Marthey.)

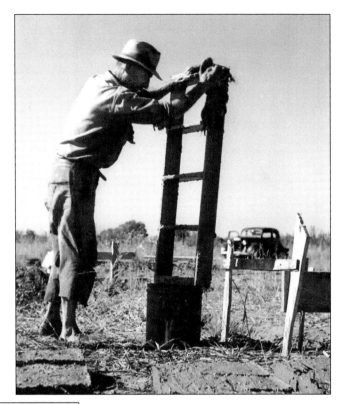

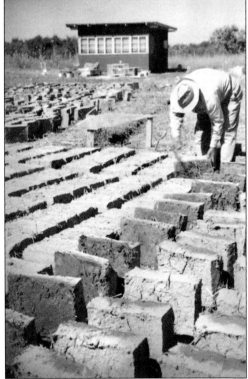

After a few days the bricks can be stood on edge to continue drying. They usually cure for about two weeks. A good brick with the right clay-soil mixture will not crack or break. The house Ken Marthey built is still standing, so the bricks must have been well made. (Kenneth Marthey.)

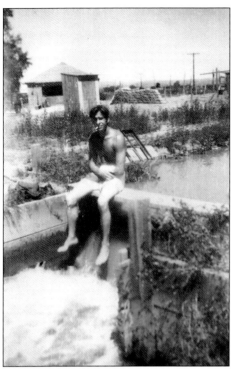

Although the *acequias* (irrigation ditches) were meant primarily to bring water to Corrales fields and orchards, they were often used for recreation. In this 1946 photograph, Vernon Maresh cools off on top of one of the *compuertas* (check dams) that raised the water level to a point where it could be diverted onto the fields. Note the stacked adobe bricks behind him. (Rosie Targhetta Armijo.)

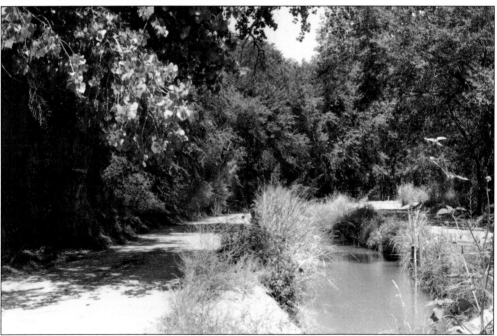

The *acequias* today not only continue to bring water for agriculture, but also provide pleasant paths on which to walk or ride. This recent photograph is of the *acequia* dug in the 18th century. Two other main irrigation ditches are the Main Canal on the west and the east side Sandoval Lateral, both constructed in the 1930s. They are maintained by the Conservancy District. (Photograph by Mary Davis; author.)

Two

FAMILIES

Corrales is home to fourth- and fifth-generation families. The village is now many times more populous than it was even 40 years ago, and these descendents now comprise less than a tenth of the population, but they provide the warp threads to the Corrales tapestry—living proof of the long history of the village.

Whenever one talks to a longtime resident of Corrales it will soon come out that he or she is related by blood or marriage to at least one or two of the old families that settled in Corrales in the 18th and 19th centuries. The 1790 Spanish census lists these names as the heads of families: Baca, Chavez, Cordova, Gallego, Gonzales, Griego, Gutiérrez, Martin (later usually written as Martinez), Montoya, Perea, and Santillanes. Within 30 years these families were joined by those with such surnames as Apodaca, Armijo, Aragon, Carrillo, Garcia, Lucero, Romero, Sanchez, Sandoval, Tenorio, and Trujillo. Some of the family surnames have disappeared completely through marriage or because every family member moved away, but an impressive number still live either in the village or within driving distance, and they proudly recount their family histories.

In the mid- to late 19th century, and particularly after the railroad reached New Mexico in 1879, the composition of the Corrales population expanded to include several Italian and French families, some Germans, and at least one Irishman, plus some Midwesterners. All but one, a coal miner, are identified as farmers in the 1910 Corrales census. Descendents of these families continue to live and raise their children in Corrales.

Not all the old families are represented in this book, but in the following chapters many of the old names appear, their lives and accomplishments immeasurably enriching life in the village.

Antonio José Santiago Gonzales farmed in Corrales all his long life, 1816–1897. With Diego Lucero, Felipe Martin, and his brother-in-law Ramon Gutiérrez, Gonzales gave the land for the old San Ysidro mission, and the Gonzales family helped build the church. Antonio José's great-grandfather, Andres Facundo, gave land that his descendent, Hector Gonzales, believes became La Entrada, the first public road across the grant. (Hector Gonzales.)

Herman Gonzales (right) was one of Antonio José's Santiago Gonzales's several sons; he posed here with his nephew, Elias Gonzales, in the early 1920s. Herman worked on Corrales farms as well as being employed by the City of Albuquerque as a plumber from 1927 to 1943. He was a deeply religious man and took care of the old San Ysidro mission church. (Hector Gonzales.)

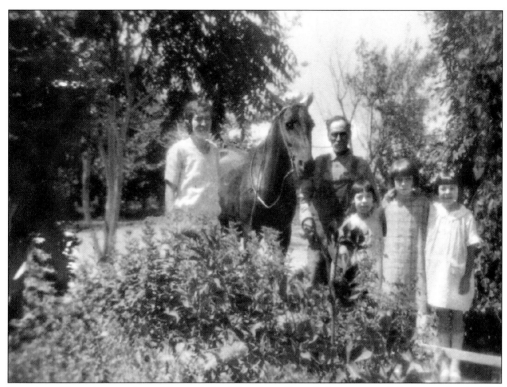

Francisco Gonzales, another of Antonio José Santiago Gonzales's sons, stands in his garden in 1926 with his horse, his daughter Sofia (far left) and (from left to right) Flora Martinez, ? Clancy, and Soledad Contreras. Sofia was Soledad's aunt and raised her after her sister Juanita died in the 1918 influenza epidemic. Soledad married Pedro Palladini Perea in September 1940. (Frank Perea.)

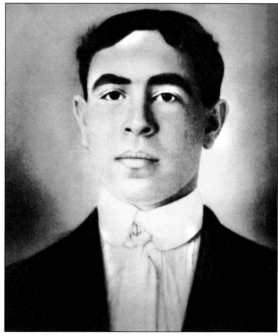

One of Francisco Gonzales's sons, Alejandro (shown in a c. 1910 portrait), made a name for himself as a progressive farmer, especially for his celery, not a traditional New Mexican crop. A 1924 Albuquerque newspaper predicted a great future for celery in New Mexico based on Gonzales's experience. In that year, Gonzales, called "the Celery King," sent a gift of celery to Pres. Calvin Coolidge for Christmas. (Antoinette Silva.)

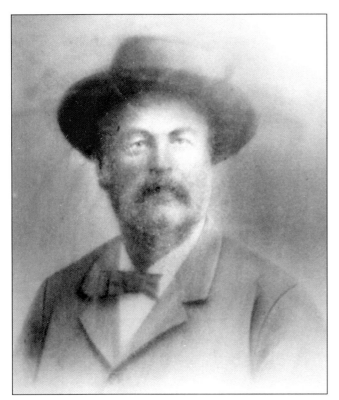

Another branch of the Gonzales clan was descended from founder Juan Gonzales Bas through Juan Cristobal Gonzales, a brother of the great-grandfather of Antonio José Santiago Gonzales. Juan Cristobal Gonzales's son Santiago and Santiago's son Ignacio (pictured at left, c. 1890) were two of the richest men in the village in the 1870s. (Philip Jonkers.)

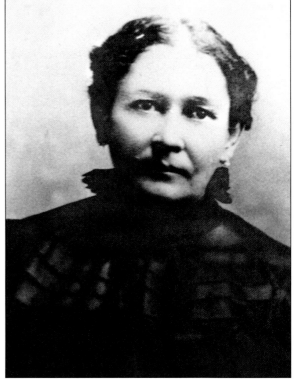

The Santiago Gonzales House, with 30 to 40 rooms, was the center of a large hacienda that employed many workers. Some of its rooms are still standing. Ignacio Gonzales married Maria Avelina Garcia (right) from a prominent Los Ranchos de Albuquerque family, and they had at least eight children. (Philip Jonkers.)

Candido Gonzales, one of Ignacio's children, built himself a frame house, unique in Corrales to this day. It is shown here in a late-1930s photograph by Paul A. F. Walter Jr. Candido was reportedly a dealer in mules and often traveled to Kansas City on business. When mules were no longer profitable, he raised goats, and his home was known as the "Goat Farm." (Stanford University Library.)

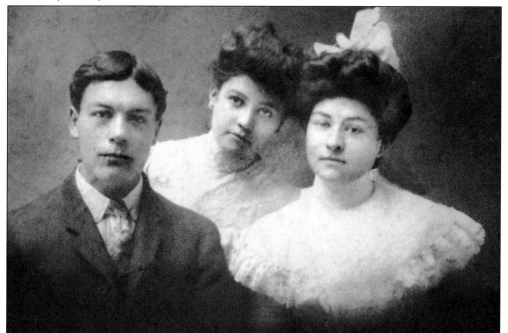

Three of Ignacio Gonzales's children, Carlos, Candelaria (center), and Beatriz posed for their portrait around 1900. Beatriz later married Richard Heller and went to live in Cabezon, New Mexico, to help him run his general store there. (Philip Jonkers.)

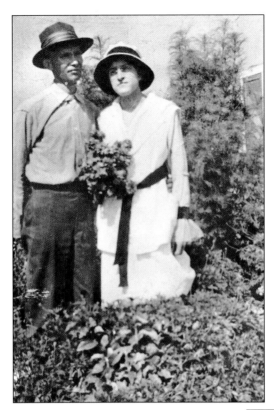

Francisco "Frank" Gonzales is shown at left in 1917 at his marriage to Altagracia "Grace" Martinez. Frank's mother, Ester Armijo Gonzales, the wife of Ignacio Gonzales's son Conrado, built the *terrón* house that Frank inherited. He and his wife ran the front of the house as a post office and grocery store from 1939 to 1959, at one point adding a gas station at the north end, one of the first in Corrales. (Linda Gonzales.)

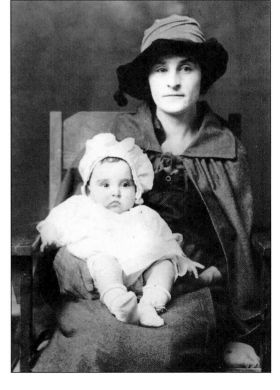

Grace and her son Conrad are shown at right in 1922. Conrad received a degree in civil engineering in 1945 and later worked as Albuquerque's chief water engineer. He developed and built the world's first closed-loop automatic control water system while working for the city. (Linda Gonzales.)

Born in 1835, Encarnacion Lucero was the matriarch of a large Gutiérrez family. She married Francisco Gutiérrez in 1852, and they had seven children, several of whose descendents still live in Corrales. The Gutiérrez family owned many acres of land around the old San Ysidro Church. Francisco's older brother Ramon was one of the donors of land for the church. (Ramona Gutiérrez Holdeman.)

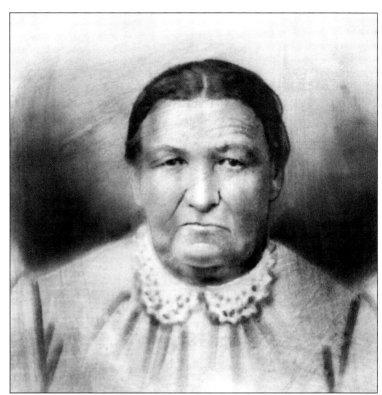

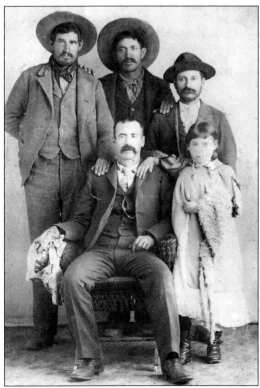

One of Francisco's sons was Jesus Maria Gutiérrez, seated here with his daughter Dorella and three unidentified men in a photograph probably taken around 1890. His son Napolion served as the village justice of the peace, and his daughter Bruna cared for the old church. (Ramona Gutiérrez Holdeman.)

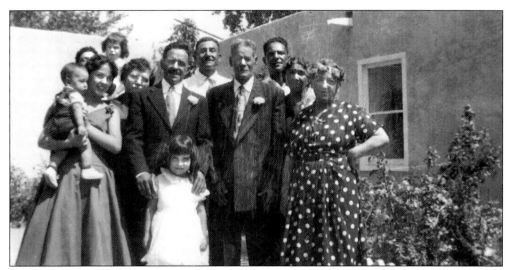

Bruna Gutiérrez Sandoval was Jesus Maria Gutiérrez's oldest daughter. She stands at right with family members gathered for the wedding of Bruna Montaño to Jim Saiz in 1954. In the second row are unidentified members of the Saiz family. In the first row, from left to right, are Dorella Montaño Aguilar with son Anthony, Sylvia Sandoval Montaño, Bernardo Montaño with daughter Antoinette, and Mr. and Mrs. Santiago Saiz, Jim's parents. (Antoinette Montaño Patterson.)

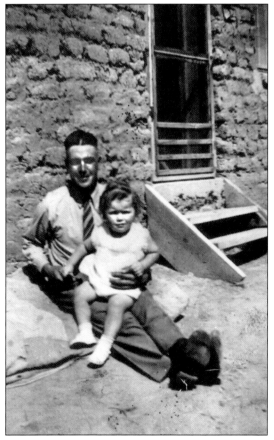

After Julianita Griego died, Jesus Maria Gutiérrez married Margarita Martinez. One of their children was Marcos Gutiérrez, who was photographed with his adopted daughter Cathy in 1938. Marcos married Ida Salce, and together they ran a large farm. Their grandson, also named Marcos Gutiérrez, trained to become a veterinarian and has his office in his grandparents' adobe home. (CHS Archives.)

In 1880, Adela Gutiérrez (shown at right in a c. 1940 portrait), a descendent of Corrales founder Juan Gonzales Bas, married José Felipe Silva, who later became the Corrales postmaster as well as Sandoval County school superintendent. Silva moved his wife and children into Albuquerque to ensure good schooling for the children; several of them became nurses or teachers. One son, Clory, served as the *mayordomo* of the Corrales ditch system before the Conservancy District was formed. After she became a grandmother, Adela Silva cared for many of her grandchildren, among them Georgia Silva, daughter of Adela's youngest son James. Georgia fondly remembers her grandmother and the chocolate treats she shared. James Silva attended the New Mexico School of Mines (now New Mexico Tech) and received the engineering degree shown below. (Both, Georgia Silva Catasca.)

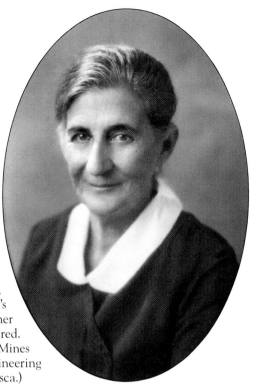

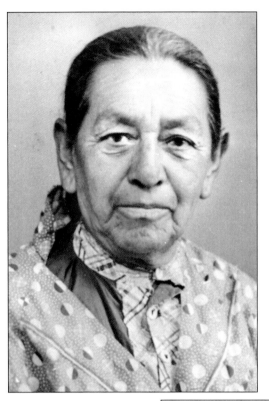

Born in 1870, Rebecca Montoya was the daughter of Nicolasa Maestas and Pedro Montoya, an Native American adopted by Tomas Montoya. She and her husband, Feliz Tafoya, had a large home in Corrales and a rented ranch on the Rio Puerco, where her son Victor and his wife lived until 1935, when Rebecca Montoya died. She had materially aided her children for many years. (Frances Tafoya Trujillo.)

In the late 1940s, Victor and Margaret Tafoya stand for their picture with their sons (from left to right) José, Agapito, Feliz, and Eugene in the late 1940s. The family had lived in Victor's mother's house until it was flooded in 1941 by an unattended irrigation ditch. They moved to a small house just west of the ditch. Victor farmed, raised goats, and worked in Ruth Owens's dairy to provide for his family. (Frances Tafoya Trujillo.)

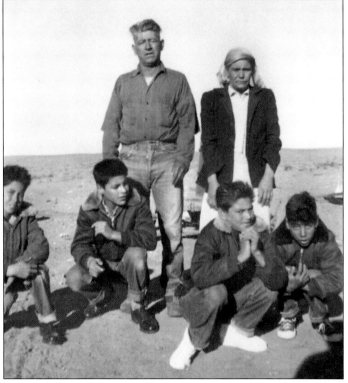

Leopoldo Martinez and Eufelia Montoya are pictured here, probably not long after their marriage in October 1898. Martinez came to Corrales from Barelas and served as an undersheriff for the county. Eufelia Montoya was from Los Montoyas at the northern end of the village. They took care of their grandson Ralph when Ralph's father, José Martinez, worked in Arizona and California during World War II. (Dolores Carrillo Esquibel.)

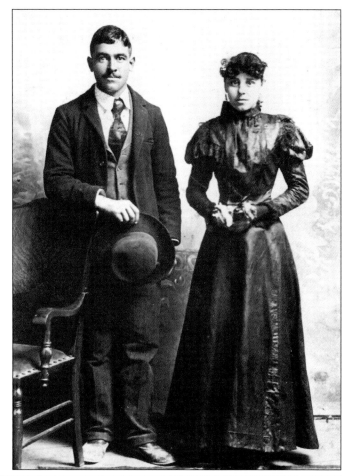

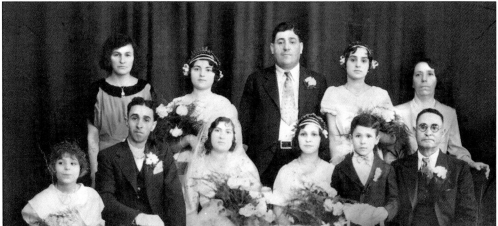

In 1933, Leopoldo and Eufelia's son José married Rosemary Trujillo. The wedding party consisted of, from left to right, (first row) the bride's sister Reina Trujillo (flower girl), José Rafael Martinez (groom), Rosemary Trujillo (bride), Frances Martinez, Charlie Romero (ring bearer), and Luis ?; (second row) Onofre Montoya, Jesusita Nuanes, José Montoya, Piedad ?, and Mrs. Luis ?. (Mayta Martinez Morris.)

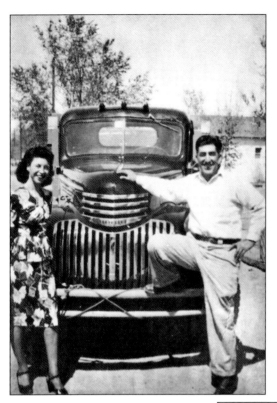

Frances Martinez, a daughter of Leopoldo Martinez, and her husband, Celso Griego Carrillo, stand happily by their 1941 Chevrolet truck. Celso (1911–1998) was born and raised in Corrales by Bonifacio and Fedelia Griego Carrillo. Fedelia Griego Carrillo's mother was Dolores Gallardo Griego, who was accidentally shot and killed in 1893 in the Imberte home (now Rancho de Corrales). (Dolores Carrillo Esquibel.)

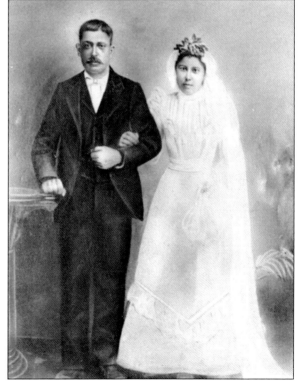

Elias Tenorio and Onofre Montoya were married in the old San Ysidro Church in April, 1899. Tenorio was born in Corrales in 1870, the son of José Tenorio and Francisca Montoya. His nephew, George Tenorio, was a prominent local politician; George's daughter Barbara was elected the first mayor of Corrales in 1971. Onofre Montoya was the daughter of José Felipe Montoya and Trinidad Gutiérrez. (Mary Richardson.)

Teofilo Perea Jr. and his wife, Trinidad Silva, photographed in 1968 in Mexico, were both born and raised in Corrales and married in 1926. Teofilo's brother bought the Tijuana Bar building in 1929 from Bonifacio Carrillo, and, in 1936, sold it to the Pereas. They ran the Tijuana Bar there, as well as a grocery store and service station. His son T. C. Perea and his wife, Stella, now own it. (Rose Cordova Montoya.)

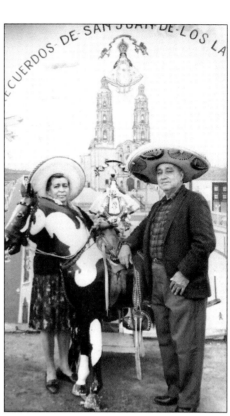

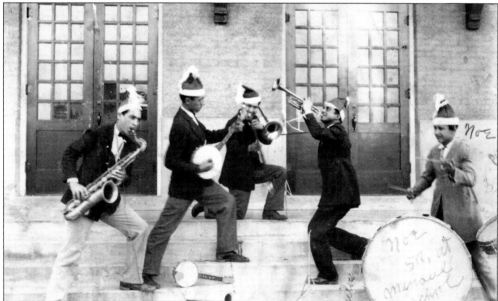

Filomena Armijo Perea married Teofilo Perea Sr., and they raised four children: Teofilo Jr., Venturita, Josefina, and Noe. Both sons went to Menaul School in Albuquerque. In this 1920s photograph of a band at Menaul, Noe Perea is playing the drums at right and James Silva (José Felipe and Adela Gutierrez Silva's youngest son) is playing the trumpet. The other band members are unidentified. (Pauline Perea.)

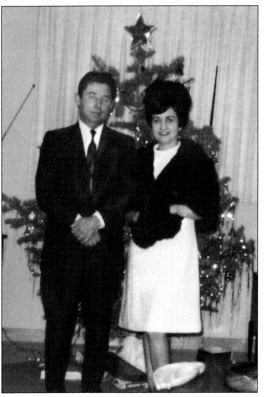

Venturita Perea sits with her mother Filomena Armijo Perea on the steps of the old Perea house, built in the mid-1800s. A notation on the photograph, taken in the 1920s, states that it was made "as the orchard was small." Venturita Perea taught and directed student presentations at Sandoval Elementary, and later earned a Ph.D. and wrote *Panoramic Spanish for Elementary Pupils* based on her teaching experience. (Pauline Perea.)

Ignacio Perea, Teofilo Perea Jr.'s oldest son, and Pauline Harrison, photographed in 1963, were married in 1953. Perea was born and raised in Corrales, and served in the Pacific with the U.S. Navy during World War II. He ran a business, Sandia Refrigeration, and also worked for the Sandia Labs engineers. He and Martin Eckert built Perea Hall in 1948. Harrison's father helped write the New Mexico state constitution. (Pauline Perea.)

Josefita Maria Armijo (usually called Fita), a great-granddaughter of Francisco Gutiérrez and Encarnacion Lucero, was the daughter of Esther Gutiérrez. She is pictured at her October 1938 wedding to Valentin Leal, whose family had lived in Corrales since at least 1850. Valentin was born in 1919, and he remembered catching wild horses on the empty grant lands and bringing them down to the Thompson Ranch. (Dianne Leal.)

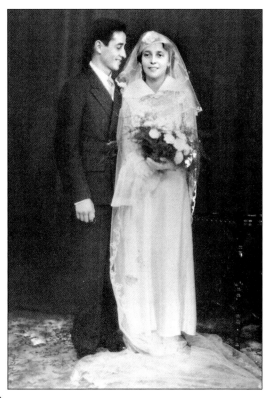

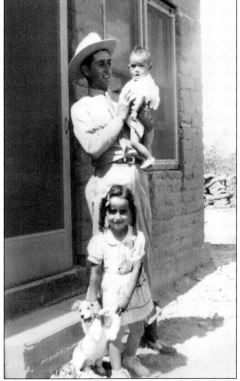

In 1943, Valentin Leal stands with his children in front of the first house he built for his family. It was later traded for another property, and he built a larger house. Standing in front with her dog is his daughter Dianne; little sister Vera Leal rests in her father's arms. Vera had been very sick at the time and was cured with Pepto-Bismol. (Dianne Leal.)

Fita Armijo's brother José Leon (left) and sister Ernestine (usually called Tina) were photographed with Joe Targhetta in the late 1940s. The Armijo and Targhetta families were close, and José Leon lived with the Targhettas for a while. The Armijos were the children of Arsenio Armijo and Esther Gutiérrez. (Rosie Targhetta Armijo.)

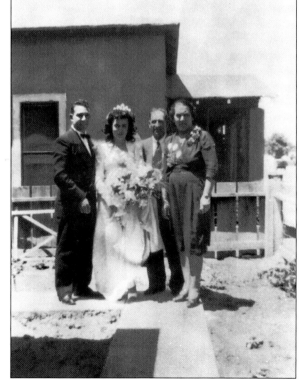

Gilbert Lopez and his bride, Eloisa Sanchez, stand with his parents, Perfecto Lopez and Anita Gonzales, in Albuquerque in June 1947. Perfecto and Anita both were from old Corrales families but had moved into the city in 1929 for the better schools. During the summer, they would return to Corrales to grow chiles, corn, beets, cabbage, watermelon, and cantaloupes, which they sold to a Piggly Wiggly store. (Gilbert Lopez.)

Ed Maes and Carmen Rivera were married in 1918 in Las Vegas, Ed's hometown. He worked in the mines near Golden, New Mexico, and in Arizona and Colorado. He also raised turkeys, which he sold locally. During the Depression, he shot and butchered cattle for the U.S. government. They came to Corrales in 1935 and soon were raising turkeys there. (Annie Maes Chavez.)

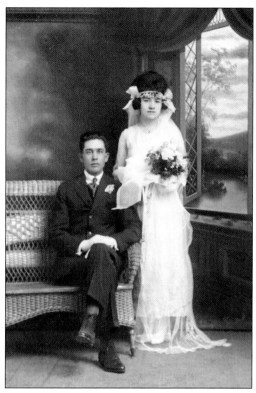

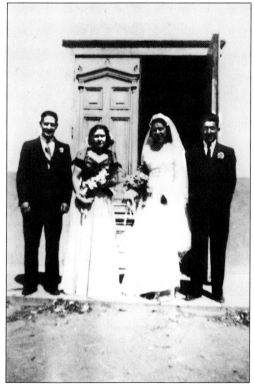

Ed Maes's daughter Annie married Augustin Chavez in June 1947. Greg and Mary Romero (on the left) joined the wedding party. Chavez was a machine gunner during World War II, and he and Annie were married upon his return and started farming. Annie had been an important helper on her family's farm; only she could harness her father's mule, skittish from years of working in the mines. (Annie Maes Chavez.)

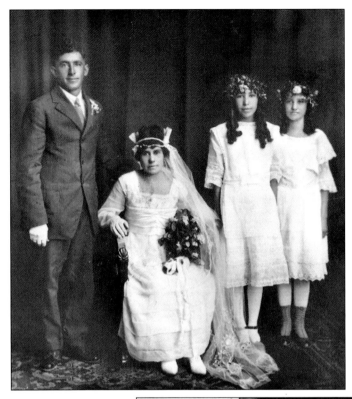

Augustin Chavez's parents were Carlos Chavez, born in Corrales in 1893, and Rosa Griego, the daughter of Justo and Luisa Griego from Los Griegos in Albuquerque's north valley. This wedding photograph was taken around 1915, before Chavez joined the army and fought in World War I. The young girls are the Moya sisters from Rosita's mother's family. (Chavez family and CHS Archives.)

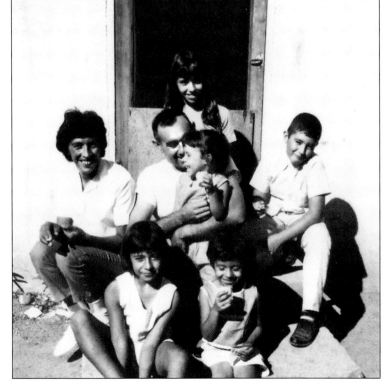

Another son of Carlos and Rosa Chavez was Justo Chavez, who posed for this family photograph in 1971. The two little girls in front are Debbie (left) and Carmen. Behind them are Chavez's wife, Mercedes Vallejos Chavez (left), Justo Chavez holding Becky, and Donald on the right. Katie Chavez is behind the group. Justo and Mercedes met at a dance. (Chavez family and CHS Archives.)

Juan Perea's father, Jesus Perea, helped build the old San Ysidro Church in 1868. Felice Mares came with her family to Corrales in 1911 from Raton, New Mexico. Juan and Felice were married in 1920. Members of the Perea family, pictured from left to right in this 1925 photograph, are Margaret, Juan, Tony, Felice, and Mable. (Viola Perea Farfan.)

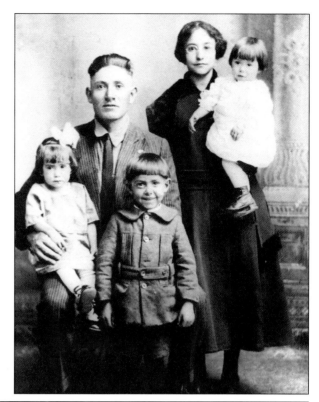

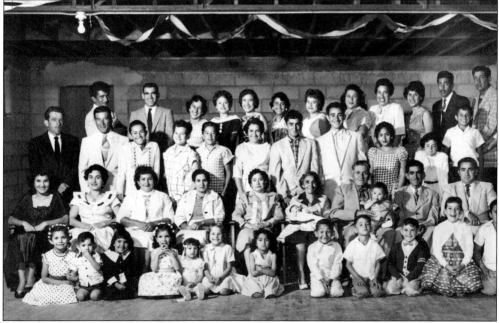

In 1957, the entire Perea clan gathered in Perea Hall in Corrales. Juan Perea is third from right in the second row, and Felice Mares Perea is next to him. The little girl fifth from left in the first row was given chewing gum so she would sit still, according to Perea family members who waited a long time for the picture to be taken. (Ruby Cordova Montaño.)

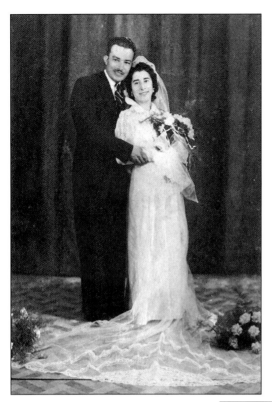

Rupert and Reymunda Lopez were married in October 1939 and settled in Corrales. Rupert was born in Albuquerque. During the Depression he worked with the Civilian Conservation Corps to build the National Park Service Region III headquarters building in Santa Fe. He and his wife met at the skating rink at Gibson Boulevard and Broadway in Albuquerque. (Rupert Lopez.)

Reymunda's father, Emilio Lopez Sr., and mother, Josefa Leyba, are pictured here at their home on Corrales Road in the 1940s. Emilio and Josefa were married in Casa Salazar on the Rio Puerco. He was a farmer, and Josefa was a homemaker who made all her children's clothes. The children helped with hoeing, chopping wood, and washing the wooden floors. The family moved to Corrales in the early 1920s. (Rupert Lopez.)

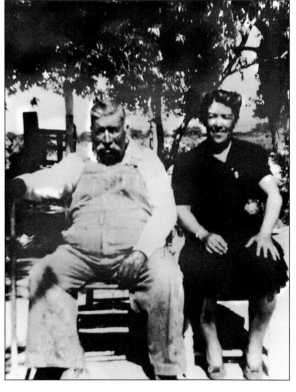

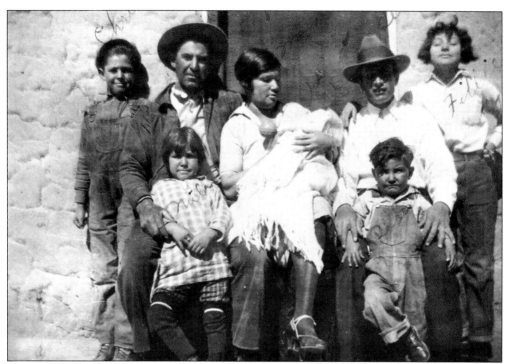

The Griego family lived near the old San Ysidro Church in a mid-19th-century adobe built by Jesusita Lucero. She was the great-grandmother of Miguel Griego, whose family inherited the house. Seen in this 1929 photograph are, from left to right, Cristino Griego; Miguel Griego with daughter Neita; his wife, Cleofas Gallegos Griego with niece Erlinda; Guadalupe Gutiérrez (Erlinda's father) with Robert Griego; and Fidelina Griego. (Neita Griego Gutiérrez.)

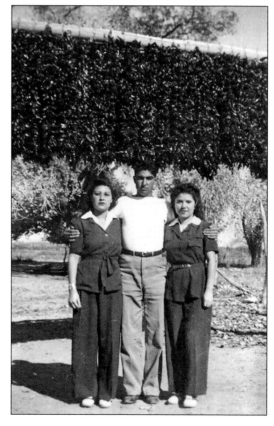

From left to right, Neita Griego, Robert Griego, and Luisa Manzanares pose in front of a rich harvest of chile *ristras* at their home in the early 1940s. Luisa was from San Luis, Colorado; she was a friend and classmate of Neita's at the Harwood Girls School in Albuquerque. Several Corrales families sent their children away to school to ensure that they got a good education. (Neita Griego Gutiérrez.)

This early-1930s photograph (above) was taken near Sandia Pueblo on the ranch Vickie Gutiérrez's grandparents rented from the Catholic Church for $25 a year. The driver is Vickie's father, Guadalupe Gutiérrez; his wife, Marianita, sits behind him, and "Mungo" is at left. Friends and relations had to get up early to attend the Gutiérrez wedding in 1926—the invitation below says it was held at 7:30 a.m. at the church in Bernalillo. This allowed time for a day-long reception at the Gallegos home in Sandoval, which had been the official post office name for Corrales since 1905. After her mother's early death, Vickie lived with her grandmother Carlota Gallegos in Corrales when she started school, and after Carlota died, Guadalupe and his mother came from the ranch to live in the house. (Both, Vickie Gutiérrez Saiz.)

Usted y familia son muy respetuosamente invitados para asistir al enlace conyugal de nuestros hijos

Marianita Gallegos y Guadalupe Gutierrez

Que tendrá lugar el Lunes 25 de Enero de 1926, a las 7:30 a. m. En la Iglesia de Bernalillo, N. M.

Depués de la ceremonia religiosa se dará una Recepción en la casa de los primeros, durante el día, en Sandoval.

ANDRES F. GALLEGOS Y ESPOSA
REFUGIO GUTIERREZ, Y ESPOSA

Alejandro Sandoval, shown at right, was considered "the rich man" of Corrales in the early 1900s. His family had ranched at San Ysidro, New Mexico, for years. Toward the end of the 19th century, Sandoval began buying land in Corrales. He was politically active and held several government posts. The story goes that after the big 1904 flood, he got local landowners to sign a paper, ostensibly to get them flood relief monies, but it was a petition to change the official post office name of Corrales to Sandoval to honor his father, Francisco Sandoval. The house shown below belonged to the Sandovals; it stood opposite the elementary school and was unlike any other in the village. It burned down in the early 1930s. (Right, M. Helen Sandoval; below, Sandoval County Historical Society.)

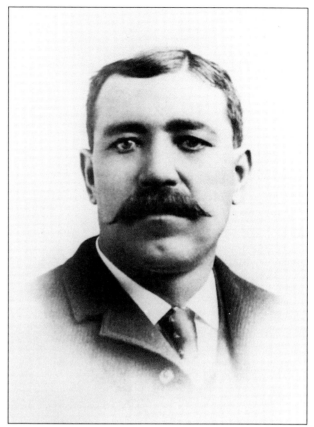

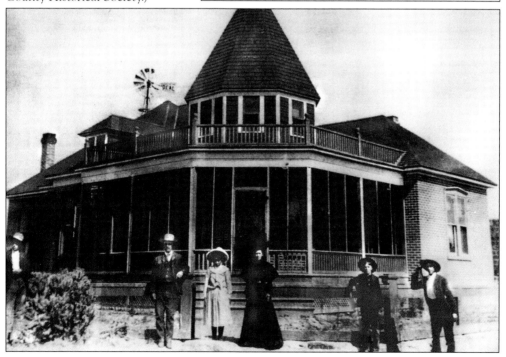

Jacobo Sanchez and his son Benjamin and a burro were photographed around 1910. Jacobo's wife was Josefita Flores from Guadalupe on the Rio Puerco. The Sanchez family has lived in Corrales for at least four generations, and their 100-year-old house is still standing. (Juanita Sanchez Garcia.)

Benjamin Sanchez, now an adult, stands on a portal with his wife, Josie Candelaria, in this photograph, probably taken in the 1940s. Josie was the daughter of Constancio and Juanita Candelaria, and grew up in an adobe house across from the old San Ysidro Church. Her home is now a historic museum called Casa San Ysidro. (Juanita Sanchez Garcia.)

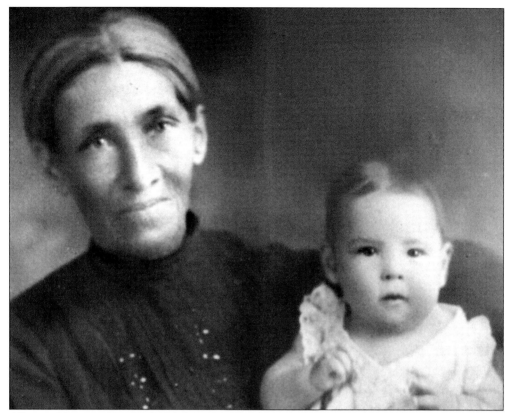
Albinita Montoya Sanchez holds her granddaughter Elena Lucero in this 1912 portrait. Born in 1847, Albinita was the daughter of Tomás Montoya and Juana Gutierrez from Corrales. She worked as a midwife and married Jacobo Benino Sanchez in 1867. They had four children: Mariana, Jacobo, Dulcinea, and Amalia. Mariana married Augustine Wagner in 1883. (Aline Lucero.)

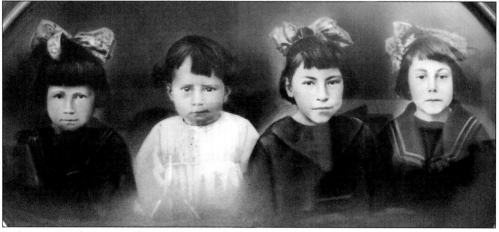
Dulcinea Sanchez married Jesus Maria "Chama" Lucero, and they had eight children. Four of them are shown in this c. 1918 portrait. From left to right are Erlinda, Cleotilde, Elena, and Soraida. Soraida died when she was quite young, and Cleotilde died in her twenties. Erlinda and Elena both lived to a ripe old age. Lucero and his wife are buried in the San Ysidro graveyard. (Aline Lucero.)

Mariana Sanchez and Augustine Charles Wagner's sons, (from left to right) Bennie, Augustine Jr., and Reggie, were photographed around 1920. In 1910, the Wagners were living in Albuquerque with Mariana as the head of the family. In that year, however, Augustine Jr. bought 100 acres in Corrales; his son, Augustine III (usually called Gus) is still farming, and the Wagner farm is going strong. (Wagner family.)

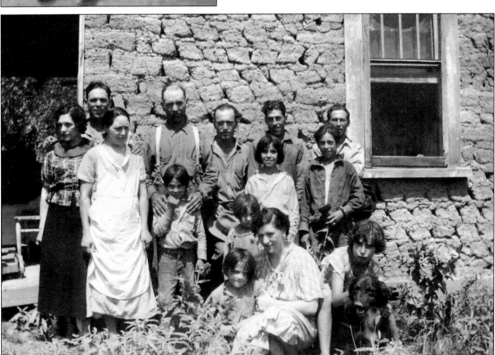

The Wagner and Sanchez families gathered at the Corrales farm in the 1930s. Standing from left to right are Elsie Wagner, Frank Sanchez, Trinidad Sanchez (Frank's sister and Augustine Wagner Jr.'s wife), Augustine Wagner Jr., Bennie Wagner, Clovis Sanchez, and Bennie Sanchez. Seated in front is Lucy Wagner. The children are unidentified. The building behind them, constructed of *terrones*, was the first Wagner home in Corrales. (Wagner family.)

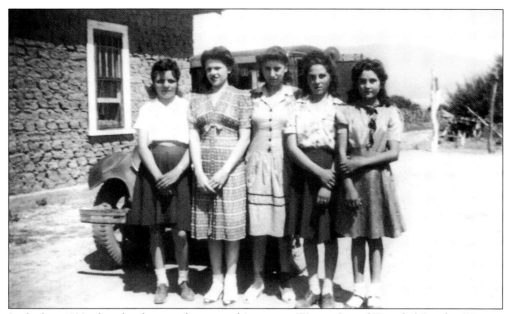

In the late 1930s, four daughters and a niece of Augustine Wagner Jr. and Trinidad Sanchez Wagner stand in the Wagner farmyard in front of the family Model T. From left to right are Adela, Mary, Melba (niece), Sophie, and Eva. Gus Wagner (Augustine III) was the Wagner's youngest child and the only son. (Wagner family.)

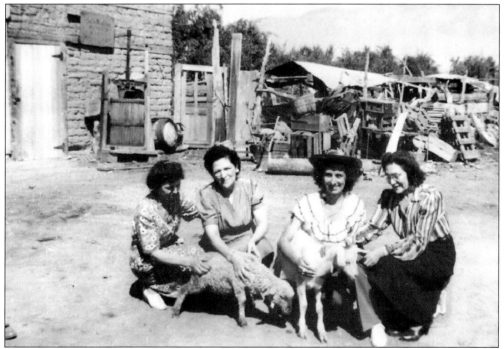

Trinidad Sanchez Wagner (far left) joined (from left to right) her sister-in-law Lucy Wagner, Lucy's daughter Melba, and another sister-in-law, Elsie Wagner, in posing for the camera with a lamb and a goat. The Wagner winery is on the left and their cider press stands by the winery door. The photograph was probably taken in the mid-1940s. (Wagner family.)

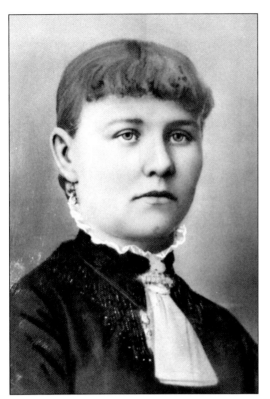

Margaret Trambley, pictured around 1895, married Eugenio Vernier in 1885. Margaret was born in Las Vegas, New Mexico, in 1869; her parents were originally from Canada. In 1882, Eugenio Vernier had come from France with his mother, Eugenia, a doctor who served the entire valley. Margaret and Eugenio Vernier ran the post office in their Corrales home from 1915 to 1938; the building is still standing. (Randolph Armijo.)

Margaret and Eugenio Vernier's daughter, Pauline, was born in 1904 in Las Vegas at her grandparents' home. She and her mother soon returned to the new home in Corrales that her father had just finished building. She is pictured with her husband, Esquipula Armijo, in the early 1920s soon after their marriage. Armijo's parents were Antonio Armijo and Juanita Montoya. (Randolph Armijo.)

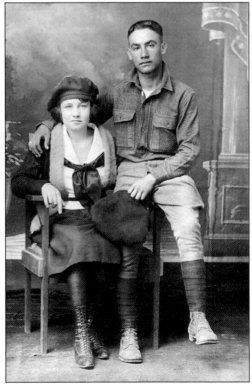

Louis Alary was born in January 1833 in the Bordeaux area of France and is shown at right in a 1909 portrait by J. M. Collumbin. A French friend in Corrales wrote him about the fertile Rio Grande Valley, and Louis and his family came to New Mexico in the 1870s. In 1879, he bought land in Corrales, and he and his sons Emile and Augustine leveled the land with a team of oxen. A friend sent him cuttings from a California vineyard, and by 1900, his farm was known as the Alary Wine Ranch. Alary also was a well driller. (Rosie Targhetta Armijo.)

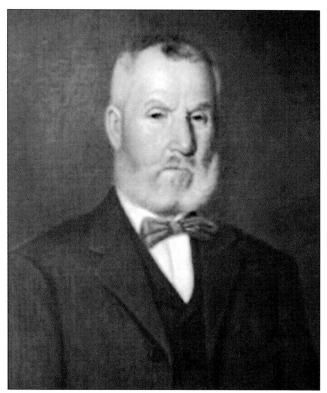

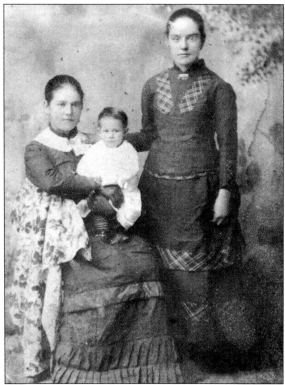

Alary's son Augustine met his wife, Lucia Larragoite (pictured standing on the right), a New Mexico native whose parents came from Spain, at Juan Bouquet's ranch in Pojoaque north of Santa Fe. (Rosie Targhetta Armijo.)

The men of the Emile Alary family stand for their photograph in the 1920s. From left to right are Emile Alary Jr., his brother-in-law August LePlat, Joe Alary, Louis DeBoute (Emile and Joe's stepbrother), and Carlos Chavez. (Annie Maes Chavez.)

Lorene and Ernest Alary, children of Emile Alary Jr., were photographed with their mother, Rose LePlat Alary, on the occasion of Ernest's 51st birthday in 1974. Ernest continued his family's successful farm operation and became one of the most respected farmers in the valley. He led many Corrales civic efforts and served many years on the board of the Middle Rio Grande Conservancy District. (Rosie Targhetta Armijo.)

Born in 1904, Roberta Alary was the youngest child of Augustine and Lucia Larragoite Alary. She married Battista Targhetta in 1922. The Targhetta family also farmed in Corrales. Battista's father, Giovanni, had brought his family to Corrales around 1912. Battista died of tuberculosis in 1943; Roberta lived on until 1997, running their farm, including doing most of the plowing. (Rosie Targhetta Armijo.)

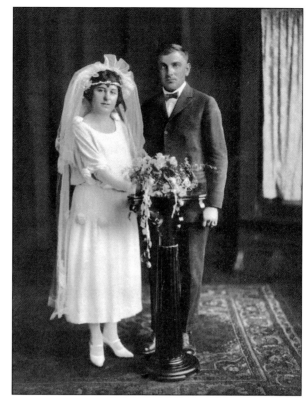

Anita and Celia Targhetta, Roberta and Battista's oldest girls, had a double wedding in 1946. Anita is the bride on the left, next to her new husband Raymond C. De Baca. Her sister Celia is the bride on the right, next to her new husband Vernon Maresh. Their sister Rosie is seated second from right, and their brother Joseph is standing at left. (Rosie Targhetta Armijo.)

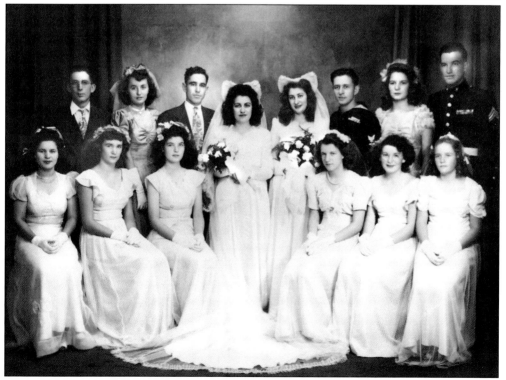

Around 1940, Battista Targhetta sits in front of a *terrón* wall at the house built near the bosque by his wife, Roberta Targhetta, with help from her cousin Louis DeBoute. The root-filled *terrones* were probably cut from damp earth in the bosque, which often flooded. Many of the buildings constructed around the beginning of the 20th century were built of terrones. (Rosie Targhetta Armijo.)

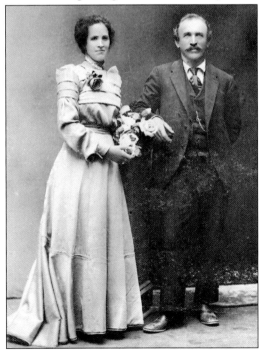

Angelo Salce and Maria Nechiari, a mail-order bride from Lucca, Italy, were married in 1903. Angelo, an Italian boot maker, came from the town of Sedico via Vera Cruz to Albuquerque in the 1880s. He arrived in Corrales in 1889, where he bought 80 acres of land and soon sent for his brother Luigi. He and Maria had three daughters, Dulcelina, Ida, and Lena, and two sons, Virgil and Arthur, before she died in 1918. (Vivian Salce Bonner and Dorothy Trafton.)

Dulcelina Salce was born in 1904 and is shown here in the early 1920s. She cared for her siblings after her mother died and taught in Corrales and Placitas schools. She married Vincent Curtis from Wisconsin in 1928 and took over the farm when he got work at a lumber mill during the Depression. She spearheaded many agricultural organizations and was on the first Corrales village council. (Losack family.)

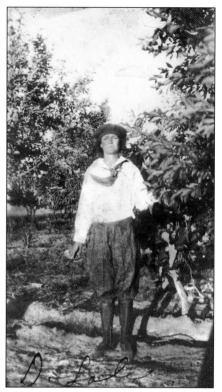

Ida Salce, born in 1907, is pictured here in the 1920s in front of her home. Once asked to join the circus because of her expert horsemanship, she would ride out on the mesa to lasso wild donkeys. Ida Salce and her husband, Marcos Gutiérrez, adopted two children, Kathy and James, and she was also the unofficial mother or grandmother to all the children in her extended family. (CHS Archives.)

Born in 1911, Lena Salce, pictured here in 1929, was the youngest of the Salce girls. She worked as a beautician, as housekeeper for the Lovelace family, and in the Albuquerque High School cafeteria. After her marriage to Candido Apodaca, she used her energy and knowledge to help run their farm, as well as farming for other families. Her daughter Charlene calls her a free spirit. (Charlene Whiteman Davis.)

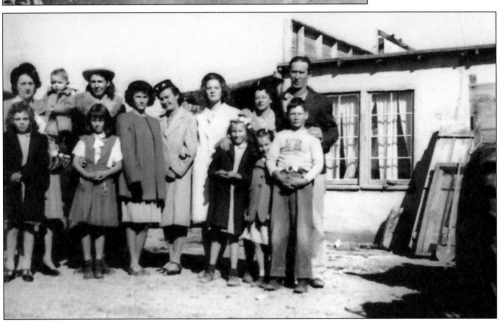

The Salce children and grandchildren were photographed in the 1940s. From left to right are Cathy Gutiérrez and her mother, Ida, with baby James; Lena Salce Apodaca with daughter Charlene Whiteman; Dorothy Curtis; her mother, Dulcie Curtis; Evelyn Curtis; and Virgil Salce with his wife, Kathleen Curtis (Vincent's sister), and their children, Bertha, Vivian, and Richard. Another son, Arthur Salce, died when he was 28. (Charlene Whiteman Davis.)

Three

FARM LIFE

Today few Corrales residents derive their living from the land, but the centuries-old agricultural way of life lives on in the village. The 18th-century irrigation ditch still provides water to fields and orchards, though far fewer than graced the landscape even 40 years ago. Food crops such as onions, lettuce, radishes, carrots, and cabbage introduced by the Spanish are grown here, as are chiles, corn, and squash—crops cultivated by the Pueblo Indians before the Spanish came. The Spanish also brought fruit trees and grape vines, and orchards and vineyards still intermingle with new homes in the village.

Farmers from Italy and France expanded the cultivation of the Mission grapes brought by the Spanish, adding a wide variety of California grapes. For 50 or so years, Corrales became known for the production of wine, and, during Prohibition, notorious for the production of whiskey and brandy.

The first commercial fruit orchard was planted possibly as early as the 1890s, and by the 1940s, much of the valley was covered with orchards. Local farmers raised more than 12 varieties of apples, as well as peaches, plums, cherries, pears, and apricots.

The common grazing land that extended for miles to the west was lost to the residents in the early 20th century. In the following years, a succession of ranchers raised cattle on these wide-open spaces until the late 1950s when the land was sold for one of the largest real estate developments in the country. Raising livestock is now done on a much smaller scale, and Corrales is home to corrals and pastures that accommodate horses, sheep, goats, and cattle, as well as a smattering of llamas, alpacas, ostriches, camels, chickens, geese, turkeys, guinea fowl, and peacocks.

Residents recently initiated a farmland preservation program to buy development rights on farm fields to keep them in production, and the village has made an outright purchase of a few cherished agricultural acres on Corrales Road in the center of the village. Growers bring their produce to the Growers Market held from April through October, and the autumn Corrales Harvest Festival annually celebrates Corrales' long agricultural heritage.

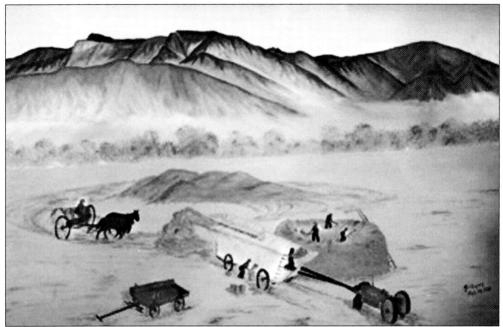

The flavor of farming in Corrales in the early 20th century is captured in these oil paintings by Corrales resident Gilbert Lopez. The scene above is of threshing wheat in 1936 on his grandfather's land. The wheat sacker was Angelo Salce; on the stack are his daughters. Gilbert's uncle Max is cutting the wheat bundles loose, while Gilbert is on the hay rake driving the mules Jenney and Jack. The wheat was usually taken to the Four Star Flour Mill in Albuquerque. The scene below depicts the water wheel installed by Gilbert's father upon his return from World War I to irrigate land above the old *acequia*. The house was built in 1906 and the bridge in 1895. (Gilbert Lopez.)

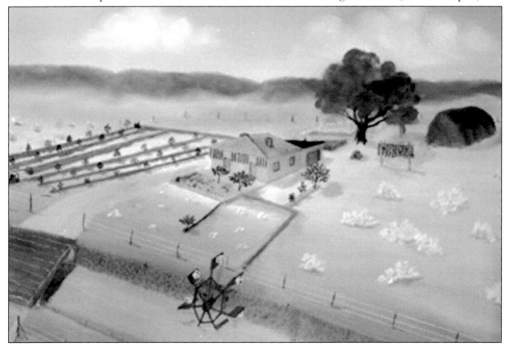

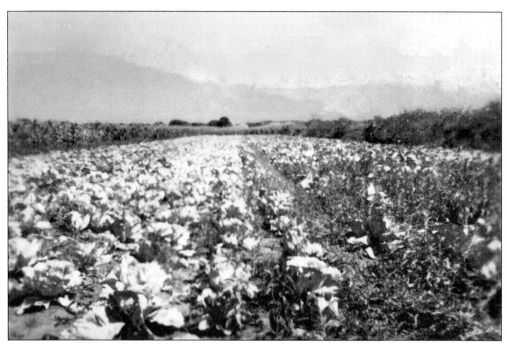

The Lopez wheat field had been replaced by cabbages and corn by the 1940s, when this photograph was taken. The cabbage was sold to a German to make sauerkraut. Cabbage was a valuable crop, as it kept through the winter without spoiling. Before the Conservancy District acquired land along the Rio Grande in the late 1920s, this field and many other Corrales properties ran to the river. (Gilbert Lopez.)

The most extensive farming in Corrales today is done by the Wagner family, who presently own 25 acres in the village and lease 70 more. This photograph, taken in 1973, shows the Wagner lettuce fields on some of the 80 acres leased then from the Sandia View Academy. The man standing by the *contra acequia* (a private ditch) is Gus Wagner's brother-in-law Waldo. (Wagner family.)

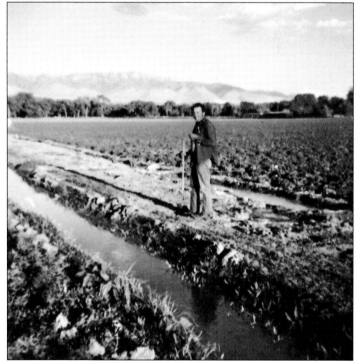

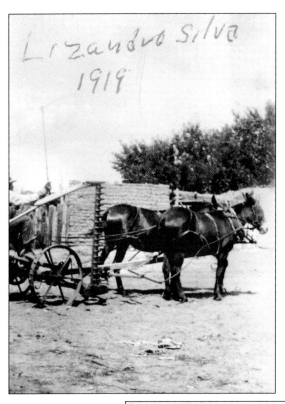

The two mules pulling a mowing machine in this 1919 photograph belonged to the Salce family and were probably lent to the team's driver, Lizandro Silva. One of the sons of José Felipe and Adela Silva, Lizandro not only farmed, but also ran a ranch and worked for Gross Kelly, a wholesale merchandiser. His wife, Aurelia, was the daughter of Eugenio and Margaret Vernier. (Georgia Silva Catasca.)

For nearly two centuries, all farm work in Corrales requiring extra power was done with a horse. This 1958 photograph is of Juan Perea and Katie, who not only pulled the alfalfa cutter shown here, but also was the fastest horse in Corrales, according to her owners. Horses were raced on La Entrada Road, one of the earliest roads in the village. (Jackie Cordova Barajas.)

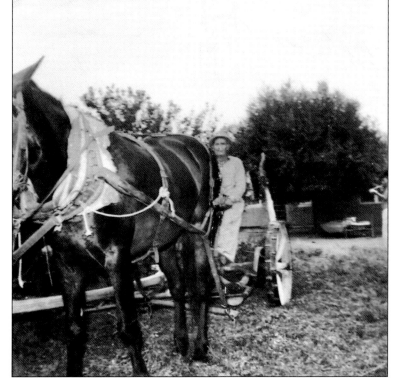

This vehicle was reportedly one of three early trucks in Corrales when this photograph was taken around 1919. The driver is Augustine Alary. Another early truck was owned by Augustine's brother Emile. A farmer named Rawlins, who hailed from New Orleans, is said to have owned the third truck. (Rosie Targhetta Armijo.)

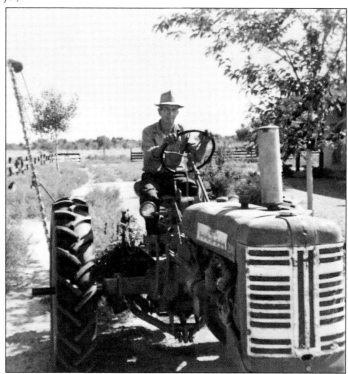

In 1968, Guadalupe Gutiérrez was photographed on his tractor on Lee Hancock's farm. Many Corrales men—and often their families as well—hired themselves out to work on other farms to make ends meet. Hancock had bought the land from the Perfecto Lopez family. It was later sold and developed as a modern housing development called the Corrales Compound. (Vickie Gutiérrez Saiz.)

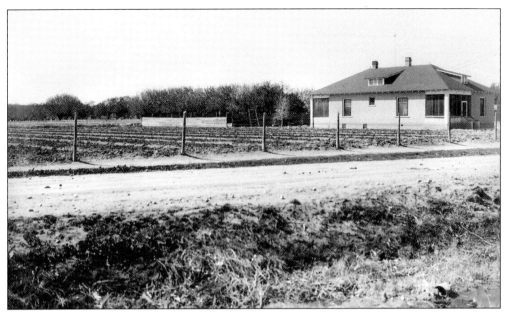

Alejandro Gonzales's farm, shown here in a 1931 photograph, was one of the largest in Corrales. In 1936, he had 90 acres in garden, field crops, and orchards, and employed 25 to 30 farm workers. He was particularly known for his production of celery, but he also grew lettuce, peas, spinach, beans, root vegetables, onions, cabbage, cauliflower, and squash to supply Albuquerque groceries. (Middle Rio Grande Conservancy District.)

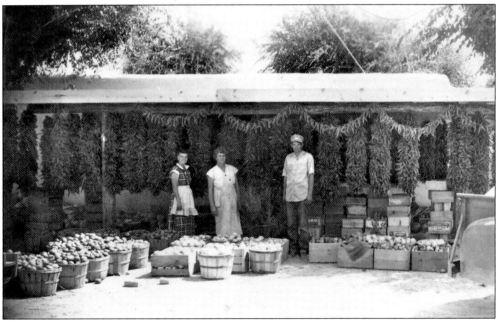

From left to right, Fran Morales, Dulcelina Salce Curtis, and Emil LePlat stand proudly at the Curtis farm stand along Corrales Road in the 1950s. The farm sold mostly apples, chiles, and yams. During the Depression, Dulcie's husband, Vincent Curtis, had to take a job with the Breece Lumber Mill in Bernalillo to make ends meet. The farm stand still fronts Corrales Road but has been converted to apartments. (Evelyn Curtis Losack.)

Chiles were a premier crop in Corrales, as were the brilliant red *ristras* (strings) made from the dried chiles. They were and are a favorite subject for New Mexico photographers. The chiles start out green and ripen into red. Here Candelaria Tenorio Griego was photographed by Dick Kent as she tied *ristras* in front of her home in 1959. (CHS Archives.)

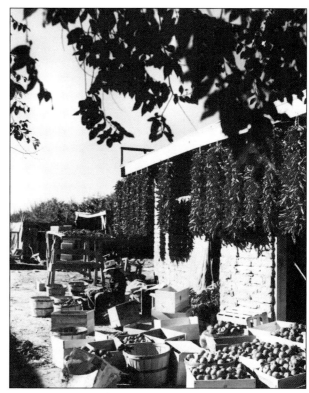

Another photograph of chile *ristras* made by photographer Dick Kent is held by its subject, Candido Apodaca, and his wife, Lena Salce Apodaca, in front of their farm stand. In the 1970s, this photograph was made into a popular postcard featuring a brilliant blue New Mexico sky behind the red chiles; the photograph was also used for place mats and trivets. (Charlene Whiteman Davis.)

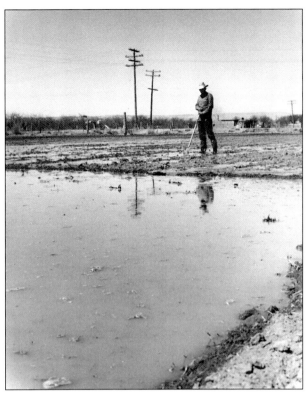

Local photographer Dick Kent chronicled much of Corrales farm life. These two 1950s photographs are of a farmer directing water onto his field. Water is carried to the field from the main canals through private ditches known as *contra acequias*. When the flow reached the field, the farmer had to use his hoe or a shovel to spread the water over the entire ground. In recent years, to ensure efficient use of irrigation water, some Corrales farmers have used laser leveling to effect an even spread of water on their acres. (Both, Kent family.)

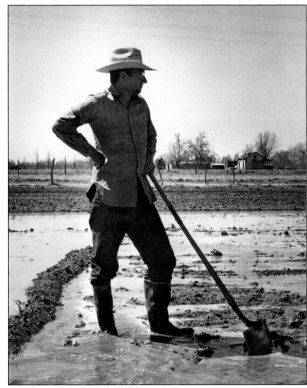

In the early 1940s, Lucy Targhetta confronts the turkeys on her family farm, or perhaps everyone is simply posing for the camera. Girls worked as hard as their brothers on the farms, and if there were no sons, the daughters did much of the farm work. Lucy's father was Battista Targhetta's brother Tony; her mother was Cleotilde Silva. (Rosie Targhetta Armijo.)

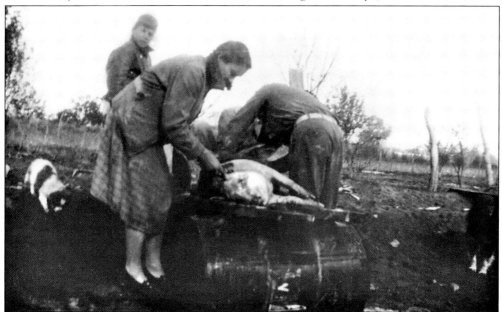

Dulcie Curtis scrapes a pig that has just been dunked in boiling water to soften its skin. Standing behind her in this 1930s photograph is her husband, Vincent Curtis. The black-and-white dog's name was Stinky; it was later killed by a neighbor. Pigs were killed and butchered in the cold months since there was no refrigeration to preserve them. (Evelyn Curtis Losack.)

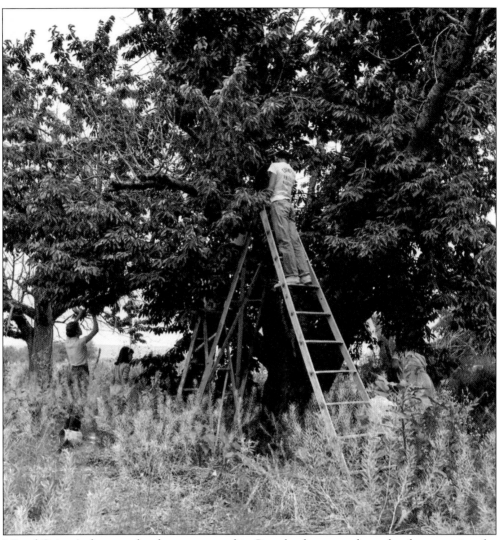

Miguel Griego's cherry orchard was renowned in Corrales, however, the orchard was nearing the end of its life in this 1965 photograph, taken by Ruth Armstrong, and today none of the trees remain. Griego bought 15 trees in 1914 for 20¢ each; they were big, black, sweet cherry trees grafted onto the root of a malaga, an exceptionally hardy wild Italian pear tree. After five years, he harvested his first crop, and eight of the trees were still producing well 40 years later. Some of them grew to 60 feet high with a circumference of 12 feet. Griego sold most of the cherries to local super markets. In June, when the cherries were ripe, harvesting them became a community affair. Miguel's daughter Neita remembers that she was not allowed to help with the picking because she always got dizzy up on the ladder. As a result, she helped her mother with the canning and still does most of the canning for her family. (Margaret Armstrong.)

An unknown photographer captured apple pickers at work in October 1939. Apples were the most plentiful crop in Corrales throughout much of the 20th century. Besides traditional varieties, Corrales apple growers raised Arkansas Black, Black Twig Winesap, Northwestern Greening, Starking, Jonalicious, Stayman, Paulared, and Tydeman's Red. Residents remember when students got out of school for three or four days in October and made good money picking apples in the Alary orchard during that time. During the 1940s and 1950s, trucks came to the village to pick up apples to sell in Texas. The aerial below, taken by Dick Kent in the 1950s, shows several of the orchards lying east of the Main Canal south of Sandia View Academy, a Seventh Day Adventist School founded in the 1940s. (Right, Museum of New Mexico; below, Kent family.)

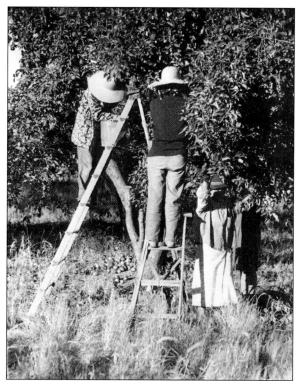

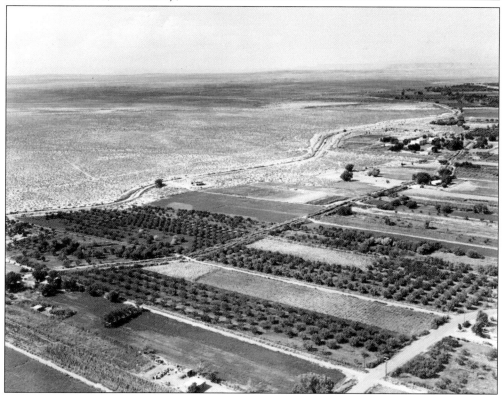

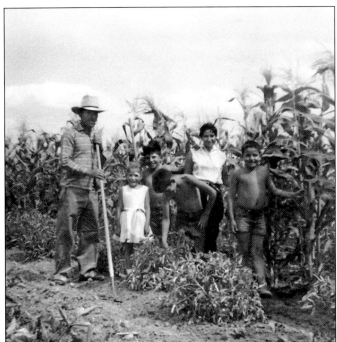

Farming was a family affair. In the mid-1950s, the Cordova family poses in their 2.5-acre cornfield. From left to right are Tony Cordova; his children Jackie, Tony Jr., and Louie; his wife, Adelina Perea; and his son Mike. Each child had to hoe his or her row (often 100 feet long) before school in the morning. They also grew tomatoes here. (Jackie Cordova Barajas.)

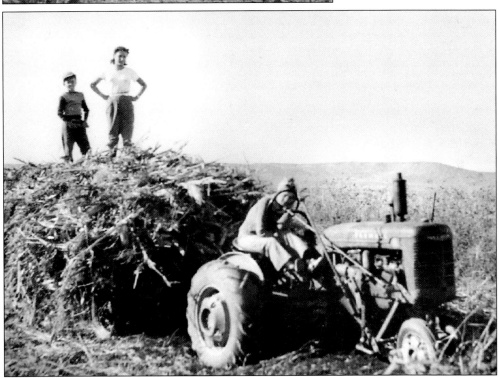

Dorothy Curtis and her cousin Charlie Beal stand atop a hay wagon, ready to stomp down the hay to pack it tight and prevent its sliding off. Dorothy's mother, Dulcie Salce Curtis, waits on the tractor for hay to be pitched onto the wagon. The photograph was probably taken in the 1940s. The Losack family still has the tractor. (Evelyn Curtis Losack.)

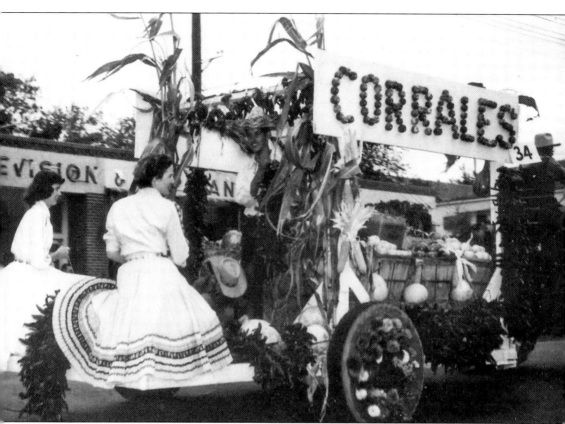

Corrales farmers participated in the New Mexico State Fair (before 1912 it was the Territorial Fair) for generations, proudly exhibiting their fruits and vegetables, and winning hundreds of ribbons. As early as 1889, Louis Alary's grape display caught the eye of a reporter from the Albuquerque paper, the *Daily Citizen*, who termed the many varieties exhibited a "gathering of nations." Among the varieties included were Zinfandel, Alicant, Maroc, Flemish, Tokai, Grenache, and Carboneau. Ida Salce Gutiérrez won so many times at the state fair that she created a huge American flag composed entirely of her ribbons. The float shown here in a 1954 photograph was the first float Corrales had ever entered in the New Mexico State Fair Parade. The two young women in fiesta dresses were Dorothy Curtis (left) and Evelyn Curtis Losack. They threw apples to the watching crowds. (Gift of Evelyn Losack, CHS Archives.)

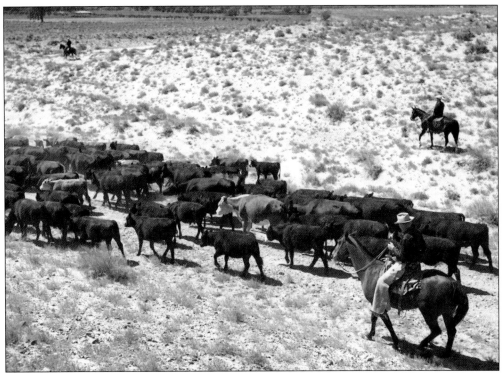

Robert Thompson and his brothers purchased 55,000 acres on the western half of the Alameda Grant in 1923. Their Alameda Cattle Company ran 3,000 to 5,000 head of Herefords on the land, as well as more than 100 thoroughbred horses. I. R. Brownfield bought the ranch in 1941, and later that decade it was acquired by the Baylor-Koontz Ranch. In the c. 1952 photograph above, taken by Harvey Caplin, cattle are being herded to the valley corrals. In the photograph by Harvey Caplin below, Casey Darnell (left) and Jasper Koontz check one of the water tanks, which is remembered by old-timers as one of the few structures on the mesa and also a great swimming hole. (Both, Koontz family and Harvey Caplin estate.)

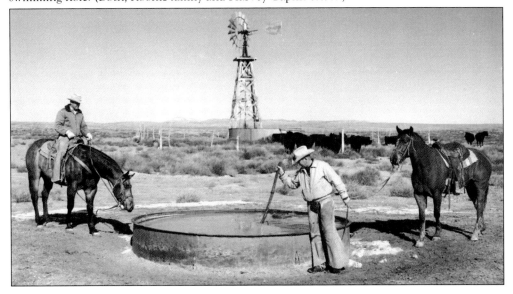

Four

THE OLD CHURCH

The first church building in Corrales stood east of the old church and much closer to the Rio Grande. Its location was its undoing, as a flood in the summer of 1868 washed it away. The Albuquerque correspondent for the *Santa Fe New Mexican* reported on July 1, 1868, that "The remorseless and irresistible Rio Grande has . . . done considerable damage in this part of the valley . . . At Corrales, the Campo Santo [cemetery] with all the remains and a number of buildings have been carried away, among them the church."

Providentially, land for a new church had been given to the Archdiocese the previous May.

The community came together to build a simple, flat-roofed cruciform structure with walls nearly 3 feet thick. It was lit by seven windows and heated by a wood stove. For many years it had only an earthen floor, and worshippers brought their own *tarimas* (simple plank benches), sat on Navajo blankets, or stood. At the rear was an 8-foot-long loft that amazingly could hold a small organ and up to 16 choir members. A pitched roof and a small sacristy were added in 1905, and some 25 years later, Andronico Mares built large tower buttresses to strengthen the front corners.

For nearly 100 years, residents worshipped at this simple Catholic mission, served by priests from a nearby parish. It was not until the 1960s, after a new church was built, that the Corrales church was granted parish status by the Archdiocese of Santa Fe. The old church, built around 1868, still stands across from the cemetery on Old Church Road. It was de-sanctified in the early 1960s and now serves the community as a venue for meetings, concerts, and art shows. Weddings are also performed there, and the rental fees are used by its caretaker—the Corrales Historical Society—to maintain the building and oversee its use.

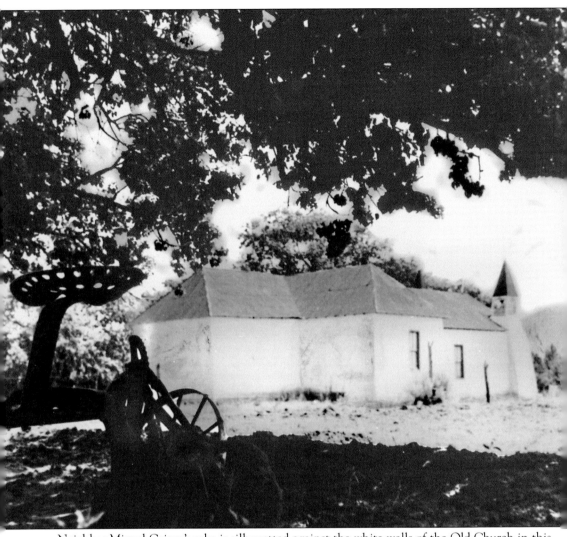

Neighbor Miguel Griego's rake is silhouetted against the white walls of the Old Church in this 1947 photograph by Cora Headington. During those years, the church was coated with a white cement plaster. The original interior ceiling of vigas and corbels was covered by a pressed blue tin ceiling, while the original mud floor was overlaid with a floor of Arkansas yellow pine. Tower buttresses had been added in the 1930s to strengthen the weakened east wall, and a concrete skirt, or *contra pared*, had been added along the base of the walls to protect them from water dripping from the roof. The bells in the towers were rung for Mass and to announce a death in the village: two somber rings for an adult and three quick rings for a child. It was an active mission, and although most of the major sacraments were performed at the mother church in Bernalillo, several baptisms and marriages, along with a few funerals were held there. (Museum of New Mexico.)

The church at Corrales was a mission of Our Lady of Sorrows, the parish church in Bernalillo. The parish priest would come to Corrales, sometimes on horseback, perhaps once a month during the early 1900s. For many years, the priest was Fr. Conrad Lammert, a German Jesuit and the priest at Bernalillo from 1914 to 1936. He was reportedly indefatigable and was also remembered as very strict. No talking was allowed during the monthly service he conducted in Corrales; he would only allow confession of "real" sins, not minor transgressions such as hitting one's brother. The Bernalillo church is pictured below in a c. 1890 photograph taken by William H. Cobb, which was restored by Walter Haussamen. The church replaced the mission at Sandia Pueblo as the parish church for Corrales. (Both, Sandoval County Historical Society.)

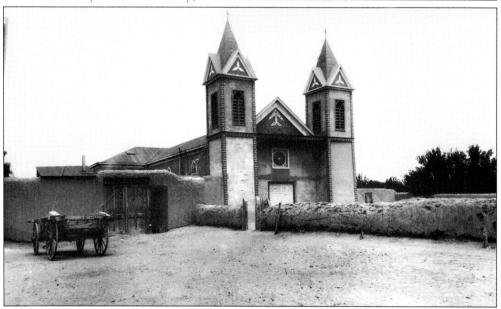

The road to the mission church and to the *campo santo* (graveyard) was called *La Entrada de las Animas* (Gate of the Souls). The road, now called Old Church Road, is pictured here in the early 1960s. Except for the addition of the wooden fence on the left and a few more trees, the view had probably not changed in decades. (CHS Archives.)

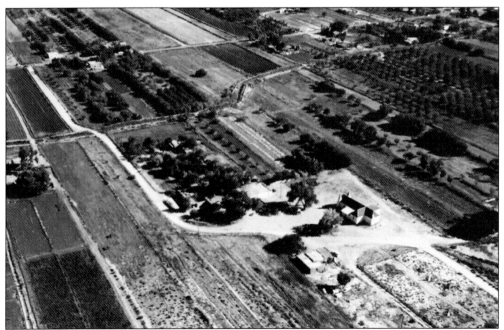

An aerial view of the area around the old church, taken around 1955, clearly shows the open fields and orchards that still surrounded the church in that year. The house to the lower left of the church was to be greatly expanded in later years and is now a historical museum. (CHS Archives.)

These rare photographs of the old altar in the San Ysidro Church were made at a 1958 first Holy Communion ceremony. San Ysidro, the patron saint of laborers and farmers, stands atop the tabernacle. During the early 19th century, the mission was called *Jesus, Maria y José* and later *La Familia Sagrada*, so it is fitting that the altar is flanked by statues of the Virgin Mary (at right in photograph below) and the Sacred Heart of Jesus (left in photograph at right). The little girl at right is Jackie Cordova; she is shown in the center of her fellow first communicants in the photograph below. (Both, Jackie Cordova Barajas.)

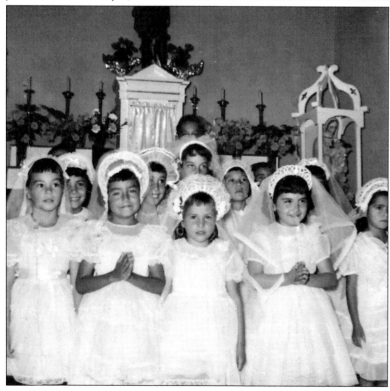

Born in 1883, Bruna Gutierrez Sandoval, who lived just north of the old church, served as the *sacristana* (caretaker) of the old church during much of her lifetime. She would decorate the altars, start the fires in the wood stoves before Mass, and keep watch on the church. In this 1940 photograph, Bruna sits with her grandson Frank Montaño in the summer sunshine. (Lillian Mares Garcia.)

The last altar Bruna decorated was for Easter 1961. This altar stood in the south transept, and its decorations lasted only the one day. *Mayordomos*—one couple from the north end of the village and one from the south—would perform most of the cleaning and preparations for the annual fiesta of San Ysidro, celebrated in May. (Antoinette Montaño Patterson.)

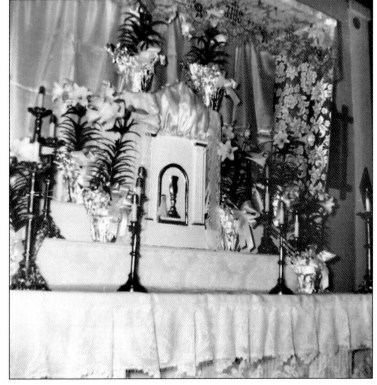

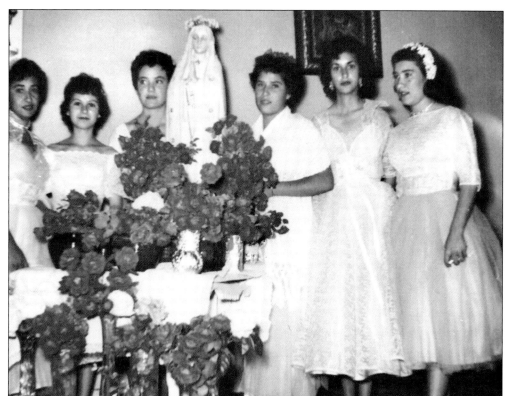

The entire month of May was dedicated to the Virgin Mary. This group of young women was in charge of the decorations for the church in May 1959. From left to right are Viola Perea, Mary Sanchez, Mary Rose Lovato, Nadine Armijo, Mayta Martinez, and Ruby Lucero. (Mayta Martinez Morris.)

Altar boy Bernardo Montano Jr. proudly stands in front of the entrance to the old church in 1946. The priest was always assisted at Mass by at least two, and usually four, altar boys. Their duties included getting water for the priest's washbasin, making sure the vestments were clean, helping with communion, and giving the responses. (Antoinette Montaño Patterson.)

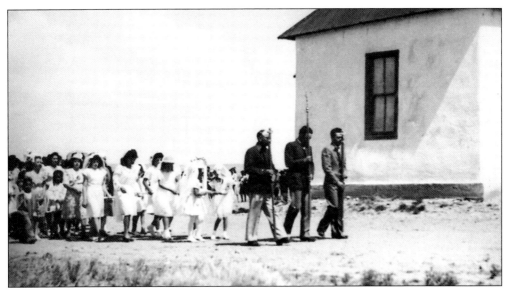

To celebrate the fiesta of San Ysidro in May, vespers were held the evening before and in the morning of the fiesta day. Church elders led a procession around the church, followed by girls in their first Holy Communion dresses carrying a small statue of the saint. The procession pictured in these two photographs took place in the 1940s. The *mayordomos* and the *sacristana* have cleaned the church, perhaps even repainting the windows or the gold-and-white altar and altar rail, and made it ready for the fiesta mass. The traditional dance that night was held in a tent when no dance hall was available. A fiesta queen was chosen, and usually there were food booths and carnival rides during the day. (Both, Evelyn Curtis Losack.)

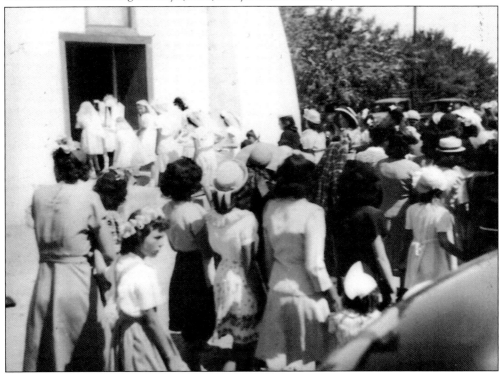

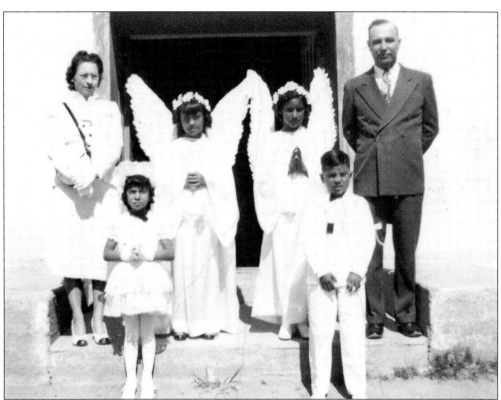

Since the Corrales church was a mission, major rites such are baptisms, marriages, and funerals were usually performed at the parish church in Bernalillo. An exception was first Holy Communion. In 1948, Lillian Mares and Frank Montaño stand by the church steps with angels Dorella Montaño (left) and Dolores Gutiérrez (right) and Mr. and Mrs. Salomon Montoya standing next to them. (Antoinette Montaño Patterson.)

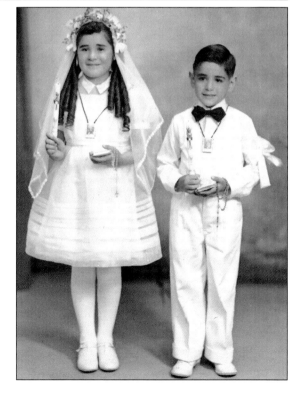

Formal photographs were often taken at first Holy Communion. Here Mary Francis and Clifford Pedroncelli pose for their portrait in 1949. When Clifford was an altar boy, he and his fellow altar boys once caught a bat in the church attic and hid it in the priest's water jug. Fr. Max Valdez was the priest then, and he gave them a good scolding. (Pedroncelli family.)

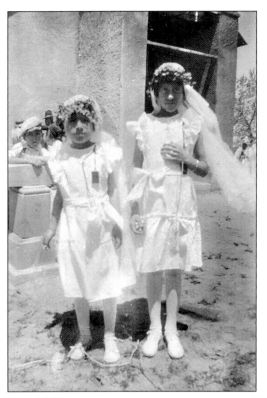

In one of the earliest available photographs of the old church, probably taken around 1935, Ernestine Armijo (left) and her cousin Esmeralda Silva are dressed for their first Holy Communion. Behind them, leaning on the gravestone is another cousin, Antonio Armijo, and behind him in the hat is Luis Chavez. At this time, the church featured a tall front entry porch. (Randolph Armijo.)

First Holy Communion dress styles had become more flowing when Eduvije (shortened to Vijes and later changed to Vickie) Gutiérrez posed in her white dress and veil in 1941. Her dress was a change from her usual outfit of homemade blouses and jumpers made from her dad's old trousers. Only her shoes came from the store. (Vickie Gutiérrez Saiz.)

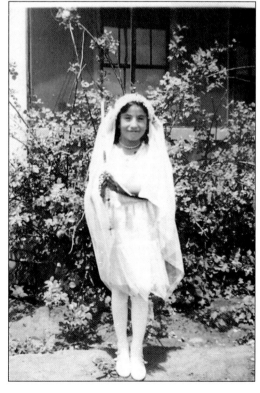

Tina Chavez Villescas stands happily with her maternal grandparents, Ed and Carmen Rivera Maes, in front of their house in Corrales on the occasion of her first Holy Communion in the early 1950s. Tina was the oldest child of Annie Maes and Augustin Chavez. (Annie Maes Chavez.)

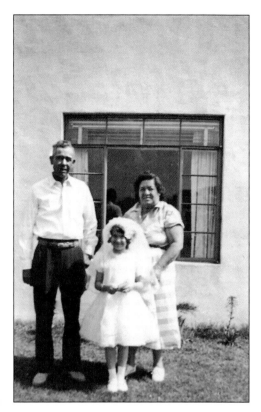

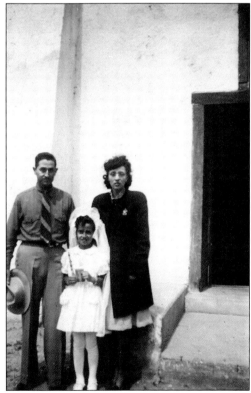

Valentin Leal and Fita Armijo Leal pose with their daughter Dianne in front of the old church on the occasion of her first Holy Communion in 1947. They celebrated later with a grand dinner. (Dianne Leal.)

By the 1950s, it became clear that the congregation had outgrown the old mission church. Fr. Paul Baca was the last priest to serve there, and he guided his flock in building a new church during most of his tenure from 1958 to 1965. He worked alongside parishioner volunteers and seminarians to build the new church on Corrales Road. (Photograph by Joe Eduvigen; gift of Inez Gabaldon, Sandoval County Historical Society.)

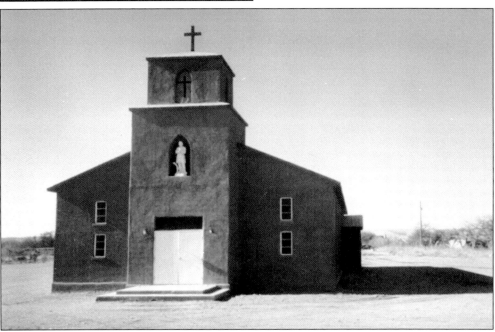

This 1962 photograph shows the completed new San Ysidro Church. Four of the old statues were brought over from the old church. San Ysidro became a parish on September 1, 1966, and the Rt. Rev. Tito Melendez was appointed as the parish's first pastor. It now has a congregation of 400 families. (CHS Archives.)

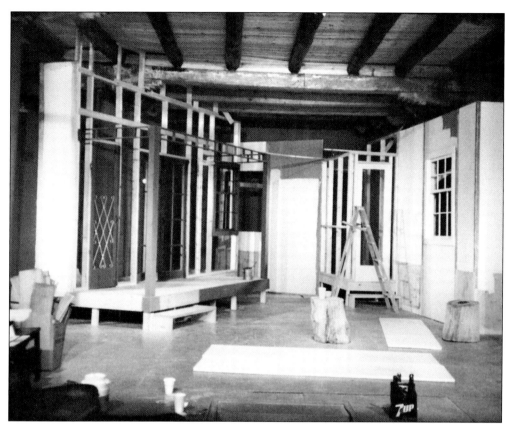

In 1963, the Corrales Adobe Theater rented the de-consecrated church from the Archdiocese of Santa Fe and began a 24-year residency, offering plays each summer ranging from *Blood Wedding*, to *Three Men on a Horse*, to *Twelfth Night*. In the undated photograph above, a set has been built into the apse, which had been extended into the nave; the church's old vigas are visible at the top of the photograph. The theater was a community effort, and many Corrales residents still fondly remember performing, working on publicity, building sets, doing make-up, and sewing costumes. At right, the main characters in *The Madwoman of Chaillot* take tea in 1967. From left to right are Caryle Poole (Constance), Wilma Brown (Josephine), Amy Bunting (the madwoman), and Elaine Strome (Gabrielle). (Above, gift of Dona Kanin, CHS Archives; right, Amy Bunting.)

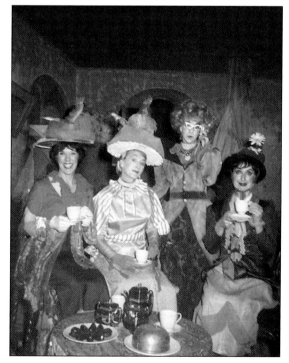

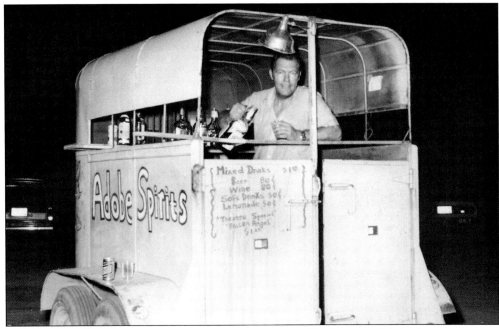

Gary Kanin serves drinks from the "Adobe Spirits" horse trailer bar in the 1960s. Kanin and his wife, Dona, were both actors and were very involved with the Adobe Theater. Kanin was elected mayor of Corrales in 1991 and served until 2006. Dona Kanin was the producer at the Adobe for several years. (CHS Archives.)

TONIGHT
Our Town

A PLAY BY
THORNTON WILDER
WITH
FRANK CRAVEN

Directed by Louise Laval

The entire action takes place in Grovers Corners, New Hampshire

The Cast
(in order of appearance)

Stage Manager	BILL CARSTENS
Dr. Gibbs	DANE HANNUM
Joe Crowell	NEIL ELLIOTT
Howie Newsome	PAT MUEHALL
Mrs. Gibbs	ROXANNE PATERNITI
Mrs. Webb	DOTTIE GREENWAY
George Gibbs	NEIL CANAVAN
Rebecca Gibbs	SHONDA GRYZIEC
Wally Webb	JOHN TURNER
Emily Webb	KATHY KATZENBERGER
Professor Willard	MERLE VOLTZ
Mr. Webb	ROSS ELDER
Woman in Balcony	HELEN SLAWSON
Man in Auditorium	JOHN SANDERS
Lady in the Box	KATHY MURPHY
Simon Stimson	TAD HOWINGTON
Mrs. Soames	JO ANNE ARIF
Constable Warren	NOURI ARIF
Si Crowell	THACKERY TAYLOR
Baseball Player	NEIL ELLIOTT
Sam Craig	CLIF GORDON
Joe Stoddard	MERLE VOLTZ
Baby	JON YOUNG

In the summer of 1979, the Adobe Theater presented *Our Town*. Corrales resident Bill Carstens, who played the stage manager, had performed at least once a summer with the theater for nearly 20 years. The Adobe found a new venue after leaving the old church in 1987 and now performs throughout the year on North Fourth Street in Albuquerque. (Gift of Dona Kanin; CHS Archives.)

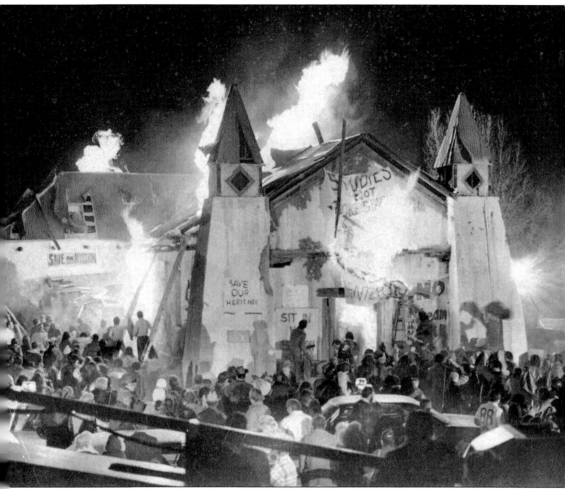

This dramatic photograph by Norm Bergsma, taken in March 1974, is of a spectacular fake fire at the old church for a scene in the television series *Nakia*. The fire saved the building. Corrales residents had become concerned about the condition of the old church, and the village government asked them to form a historical society that could purchase the building from the Archidiocese of Santa Fe and maintain it. The Corrales Historical Society was founded in 1974 and began seeking funds for a down payment for the building. Providentially, Screen Gems wanted to use the church in its television series *Nakia*. The rental cost was $1,500, enough for the down payment. When the show was over, the movie company removed all the butane gas pipes and asbestos shields, and the building was ready for renovation. The village took ownership of the church in 1976, paying the rest of the purchase price and putting the historical society in charge of the renovation and to schedule events. (CHS Archives.)

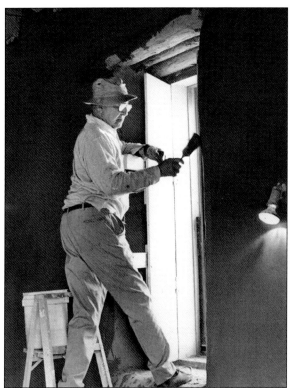

Historical society member Dr. Michel Pijoan, medical pioneer, author, and artist, was photographed by Wade McIntyre in 1983 while painting the church windows as part of its renovation. Volunteers had earlier replaced the worn metal roof and removed the tin ceiling covering the old vigas. After the theater left in 1987, the raised theater seats were removed and the interior restored. By 1989, restoration was complete, and a service annex was built. (CHS Archives.)

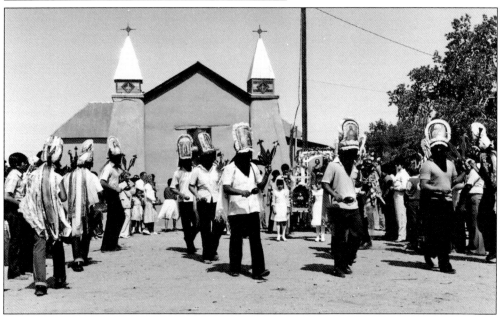

Although the old San Ysidro Church no longer holds regular church services, a special Mass has been held for many years outside the old church to celebrate San Ysidro's feast day in May. Following the Mass, the *matachines* dancers and a procession carrying statues of San Ysidro, shown here in a 1982 Ruth Armstrong photograph, walk down Old Church Road to the new church. (Margaret Armstrong.)

Five

GATHERING PLACES

The demands of farming connected Corrales residents: the loan of a horse, help with threshing and harvesting, rounding up stray stock, and assistance for someone injured in the field. But beyond the shared work of farming and meeting their neighbors at Mass or at the San Ysidro fiesta, Corraleños came together in community spaces—a dance hall, the general store, the post office, and the local school.

Corrales residents loved to dance. Space for dances ranged from the central hall of a large home to several dance halls built specifically for the purpose. When a building was not available, villagers erected a tent and brought in a wooden floor.

A few local stores supplied general merchandise, which included groceries, a few articles of clothing, dress goods, farm hardware and automobile parts, and medical supplies such as liniments and drugs. Many old-timers remember driving into Albuquerque for an all-day shopping trip to buy such foodstuffs as flour, sugar, rice, and macaroni, which could not be made at home.

The post office was also a place of meeting. For many years, the post office was located in the home of the postmaster, changing location as the postmaster changed. The granddaughter of one of the postmasters likened her grandmother's post office to the United Nations; she could hear Italian, Spanish, French, and German spoken as well as English. Even today, friends and neighbors enjoy their frequent, if chance, meetings at the Corrales Post Office.

The first school was founded around 1870 by a wealthy man named Don Inez and was supported by the Protestant Church and the county. In 1896, two public schools were established, one at the north end and one in the center of the village. These were consolidated in 1923, and a new school was built for grades one through eight. Students put on programs to which everyone was invited, and the whole village cheered the school athletic teams. Over the years, the desire to improve their school brought many families in the community together.

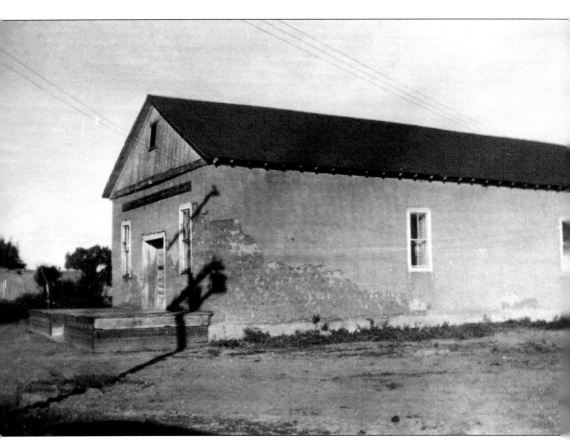

One of the oldest and least-altered buildings still standing in the village is the Society Hall, built in 1911 by the Catholic Men's Society and used for meetings and as a *sala de baile* (dance hall). Later dance halls included Florencio Garcia's hall and the Perea Hall. The Society Hall was later briefly used for a community cannery during the Depression. In the 1940s, it became Hoffhein's Garage, and in the 1960s, the front was remodeled prior to its becoming the art and craft gallery Centerline South. Since that time, it has housed a variety of arts and crafts venues and an occasional coffee house. This photograph was taken around 1938 by Paul A. F. Walters Jr. (Stanford University Library.)

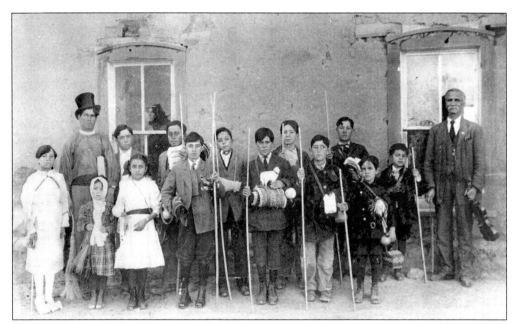

The best-known New Mexican nativity play is *Los Pastores*, in which shepherds are told by angels of the birth of Christ and travel to Bethlehem. The devil tries to stop them but is foiled by the archangel Michael. Other characters include Bartolo (a lazy shepherd), Gila (a lovely shepherd girl) and Ermitaño (the hermit). The Christmas 1910 photograph above is titled *Pastores de la Adoracion hecha por Jose de Jesus Lopez* and is thought to have been taken in front of the old schoolhouse in Corrales. The play was produced again in 1937, directed by Stella Mares (below). The Archangel Michael was played by Anacleto Montaño (center, leading donkey), who was known as a wonderful dancer. He would dance with everyone, and many learned from him. (Above, Georgia Silva Catasca; below, Antoinette Montaño Patterson.)

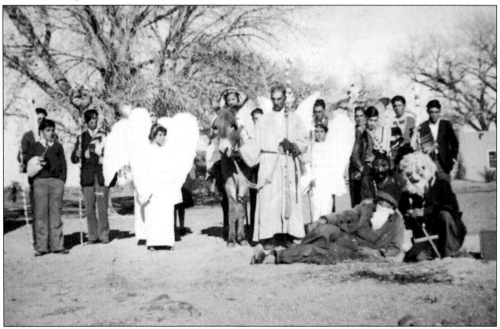

Teofilo Perea Jr. built Perea Hall after World War II to serve as a dance hall and event space. The original building contained a 90-by-29-foot hall floored with oak laid on a subfloor. In this c. 1949 photograph, Dulcie and Vincent Curtis (right) lead La Marcha as part of a fiesta fund-raiser. The fiesta queen and her escort are unidentified. (Gift of Pauline Perea, CHS Archives.)

In 1959, the community performed *Los Pastores* at Perea Hall under the guidance of actor and choirmaster Vincent Gallegos. The performance was recorded by University of New Mexico music professor John Robb. Viola Perea portrayed the Virgin Mary, and Felipe Lucero was the kneeling shepherd. Bartolo, the lazy shepherd, was played by Alfredo Rodriguez, who later became the first paid employee of the Corrales Fire Department. (Jackie Cordova Barajas.)

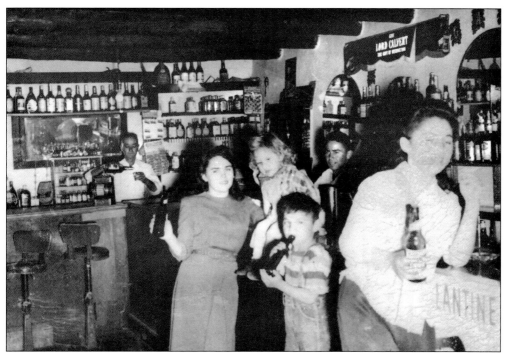

Corrales was known as a prime producer of wine and spirits, and has been home to more than its share of drinking establishments for a village of its size. The oldest still operating is the Tijuana Bar (pictured above in the 1940s), which opened after Prohibition was lifted. The 200-year-old *terrón* building was owned and managed by Teofilo Perea Jr. (at left). Next to Teofilo are, from left to right, his children Philomena, Richard, Bobby, T. C., and Margaret. T. C. later took over the bar from his father. The building is the focal point in the 1962 painting by Leo Ortiz below. To its right is a two-story house called "the Corrales Hilton" because of its apparent size. The building on the left served as Corrales' first schoolhouse. (Above, T. C. Perea; below, Pauline Perea.)

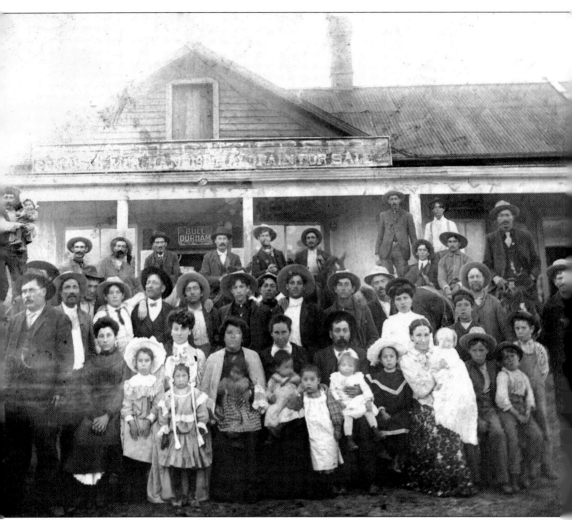

The Ignacio Gutiérrez Store was located at the intersection of the village's two oldest roads, Corrales Road and La Entrada Road. Unfortunately the store was demolished many years ago. The sign on the gable states that it offered general merchandise and grain for sale, and the sign beneath the gable advertises Bull Durham as a pipe or a cigarette. The occasion for so many people to gather for this c. 1907 photograph is unknown, and only four people have been identified. The little boy in a hat with his hands in his lap on the right end of the first row is Juan José Armijo, who was born in 1900. The second man on the left in the fourth row is Octaviano Lopez, who in 1910 bought an old building up the road and opened a general merchandise store. Ignacio Gutiérrez is seated seventh from right in the first row, and his wife, Stella Montoya, is fourth from right. Both are holding unidentified children. (Gift of Patricia Gutiérrez; Albuquerque Museum Photoarchives.)

Leal's Fountain Service opened in 1949. Valentin Leal's daughter Dianne worked there when she was 10 years old and recalled that she always overfilled the ice cream cones. Pictured here is Priscilla Leal, Valentin's sister, and her daughter Betty. Valentin later built a dance hall plus a pool hall on the property, and, with Adrian Lebian, opened the L and L Bar there. (Dianne Leal.)

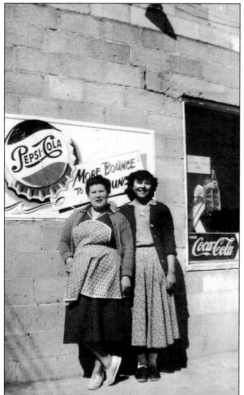

Damon Guess's store was in the middle of town, unlike the Leal store, which was farther north. The building was expanded in the 1970s into the Mercado de Maya. Frances Tafoya (right), pictured here in the 1950s with Rose Guess, started working there for $10 a week when she was 15 years old. Also a service station, the store sold groceries and oil for kerosene lamps. (Frances Tafoya Trujillo.)

When Margaret Vernier was no longer the postmaster, Altagracia (usually called Grace) Martinez Gonzales filled the position between 1939 and 1959. The photograph above was taken on her last day as postmaster. Adeline Stout (left) then operated as postmaster until 1967, working from her house until an official post office building was constructed in 1962. Adeline Stout served the community in several ways, helping to create the Corrales Community Council and its by-laws, the fire department, and the library, as well as publishing Corrales' first newspaper the *Corrales and North Valley News*. She was instrumental in getting the name of the post office changed back to Corrales from Sandoval in 1966. (Above, Linda Gonzales; left, Michael Chavez Eiland.)

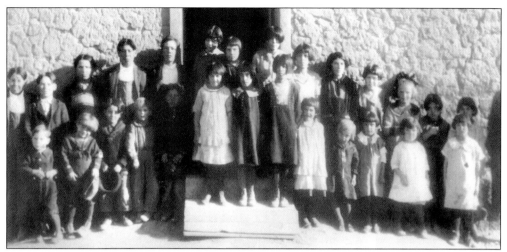

Around the beginning of the 20th century, Corrales boasted two schools, one in the north and one in the south (now the middle) of the village. The north school (above) had one room. In this photograph, taken around 1926, Valentin Leal is third from left in the first row, and his future wife, Josefita Armijo, is third from right in the same row. The "southern" school is shown below in the 1950s, well after it was no longer a school. It, too, was originally one large room. For a time it was a small store where Doña Francisquita sold candy and sundries, and then it was bought by the Perea family for their home. From left to right, Bobby Perea; his father. Teofilo Perea Jr.; and Teolfilo's brother-in-law Salomon Silva are pictured on the truck in the photograph below. (Above, Dianne Leal; below, Pauline Perea.)

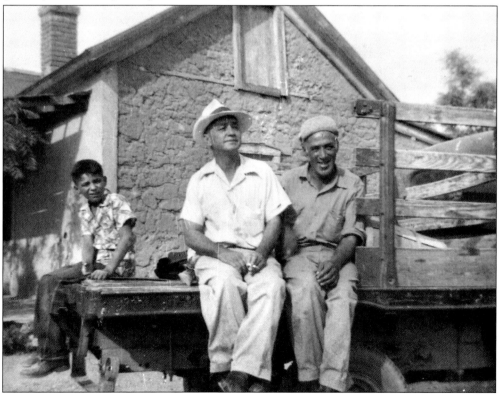

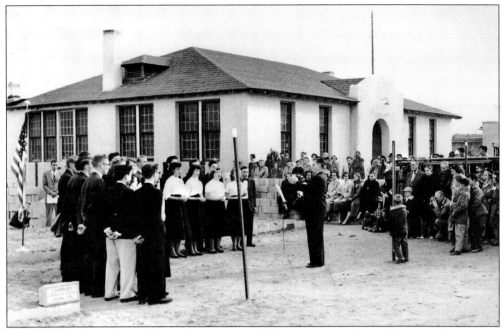

A new school was built in 1923, burned down in 1924, and was rebuilt in 1925. It had four rooms, no running water, wood stoves, and outdoor bathrooms. In the early 1950s, two classrooms, modern bathrooms, and a gymnasium/cafeteria were added. In 1955, the 1925 school was photographed when the community celebrated laying the cornerstone for a building to house the school library and the village's one fire truck. (Nora Manierre Scherzinger.)

Sandoval Elementary School included grades one through eight. Graduation, often the end of schooling, was an important milestone. Here, Lena Salce (left), Sylvia Montano (second from right), Virgil Salce (standing), and two unidentified girls pose for their 1924 graduation. Many children continued their education at Our Lady of Sorrows School in Bernalillo or in Albuquerque at Harwood Girls School or Menaul, both Protestant schools. (Charlene Whiteman Davis.)

Eight-grade graduation photographs were less formal in 1941, when this picture was taken. Teacher Mrs. Aragon is standing at left in the second row; Annie Maes is third from left in that row. The school joined the Albuquerque Public Schools in 1956. The fight to be part of that system was led by Dulcelina Curtis, George Manierre, and Ernest Alary. (Annie Maes Chavez.)

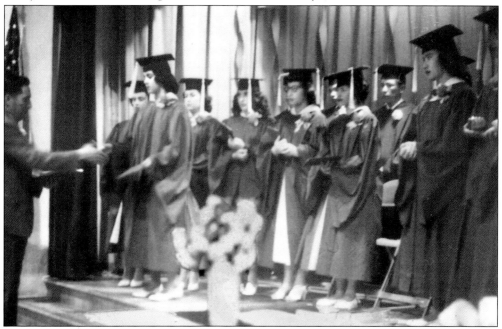

One of the last graduation ceremonies held at Sandoval Elementary School was in May 1955. The students are standing on a small stage built as part of the gymnasium/cafeteria, which was added around 1951. From left to right are unidentified, Martha Chavez (receiving diploma), Martha Alary, Mary Frances Pedroncelli, Mayta Martinez, Toni Tenorio, Alfonso Lucero, and Ruby Lucero. (Clifford Pedroncelli.)

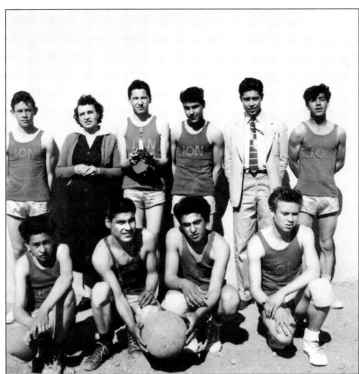

The Sandoval Lions, the school basketball team, had enjoyed a good 1955–1956 season when this photograph was taken in March 1956. The team compiled a record of 8 wins and 3 losses. The team's stars were the Tafoya triplets: Agapito (first row, second from left), and Alfonso and Eugenio, flanking coach Sotero Montoya (standing, second from right). Principal Corrine C. de Baca is standing second from left. (Clifford Pedroncelli.)

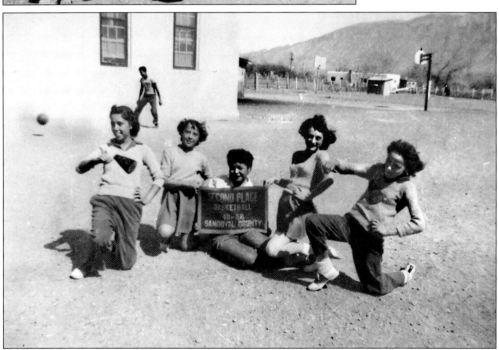

The school must have had a pretty good basketball team in 1949–1950 as well. Kneeling in the barren Sandoval Elementary School playground, these cheerleaders are celebrating a second-place finish in Sandoval County. From left to right are Vicky Perea, Dorella Montaño, Antonia Maestas, Henrietta Targhetta, and Patricia Perea. (Rosie Targhetta Armijo.)

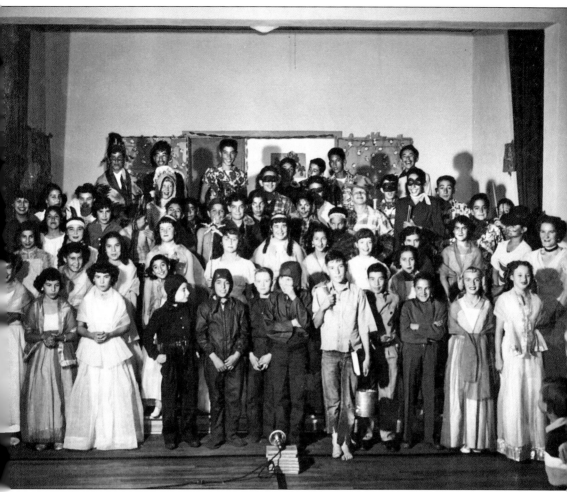

In 1952, the entire cast of a musical version of *Johnny Appleseed* fills the stage at the newly built cafeteria and stage at Sandoval Elementary School. Its director, music teacher Evelyn Curtis Losack, stands at right in the second row. Joe Reese, fifth from right in the first row, played the title role. The story included gnomes, fairies, pioneers, and Native Americans, so nearly every student in the sixth, seventh, and eighth grades had a part. Losack remembers that this was her first year teaching at the school, and she wondered if she had bitten off more than she could chew. The cast rehearsed all year, and the play was produced in the spring to great acclaim. Parents helped out with the sets and the costumes. (Evelyn Curtis Losack.)

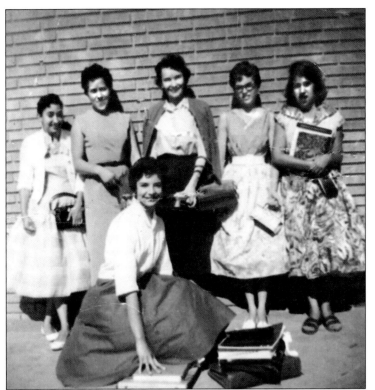

Corrales students at Bernalillo High School pose with their teacher in 1958. Mary Rose Lovato kneels in front. Standing from left to right are Viola Perea, Maria Rita Lucero, their teacher (unidentified), Lucy Marquez, and Dahlia Perea. Even before Sandoval Elementary School's 1956 consolidation with the Albuquerque Public Schools, school bus transportation was available for graduates to both Bernalillo High and to Valley High School in Albuquerque. (Ruby Cordova Montaño.)

Oh, those big 1950s skirts! In this 1955 photograph, Sandoval Elementary School students (from left to right) Irene Martinez, Martha Chavez, Alfonso Lucero, Mary Frances Pedroncelli, Lillian Gutiérrez, and Clifford Pedroncelli face the camera, with Billy Sierra kneeling in front. The Pedroncellis and Billy Sierra went on to Valley High School after they graduated from Sandoval. (Ruby Cordova Montaño.)

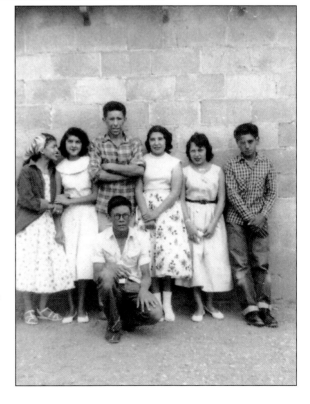

Six

Growing Up in Corrales

Growing up in Corrales meant days spent in a world of open fields and orchards, water flowing in ditches and drains, and farm machinery and animals. For longtime Corrales residents, childhood memories are mostly of the farm chores performed each summer and before and after school, responsibilities that would expand in their adult years. These years of hard work were enlivened by the pleasures and adventures of living in a world open to exploration. The poorer children learned how to make do with the simplest of toys: cars from sardine boxes with sewing spools for wheels, dishes and pots and pans made with clay from the ditch, and bubbles from washing soap and water blown through thread spools.

Farm families expected every child to do their part on the farm. By the time a child was six or seven, he or she was given explicit jobs, which included pumping water (indoor plumbing was rare until the 1950s) for both the household and the farm animals, watching over the livestock, chopping wood and bringing it indoors for the woodstoves, and hoeing their rows of crops—each usually at least 100 feet long. If the family had a tractor, both boys and girls learned to drive it at a young age. They learned how to butcher livestock and how to catch wild food, such as frogs, fish, or turtles. They learned about edible wild plants and foraged for these along the ditches or on the sand hills.

Most of the families who moved to Corrales after World War II did not come expressly to farm, so the demands on their children were not as great. These families raised some crops and kept some animals, but keeping the farm going did not create a situation in which it was critical that every member of the family had to perform daily farm chores. Most children belonged to the local 4-H club and learned about life in a rural community. They also enjoyed swimming in the irrigation ditches or boating on the larger riverside drains, riding horses across the fields and up on the mesa, and exploring the bosque, the cottonwood forest along the river.

Neita and Roberto Griego pose in front of a window in their old adobe house in 1928. Their mother, Cleofas Gallegos Griego, had covered the window with a green tapestry for the picture. Neita was born in the old house, but the midwife never sent Neita's birth certificate to the family. (Neita Griego Gutiérrez.)

Seferino (left) and Tony Perea, his elder brother, were captured on film in 1927. Tony was the oldest child of Juan Perea and Felice Mares Perea. He attended Menaul School and later worked for a local building materials manufacturer. Seferino grew up and became a restauranteur, with three restaurants in the Albuquerque area. (Viola Perea Farfan.)

Siblings Frankie and Maria Magdalena Perea, born a year apart, were photographed in 1945 outside their home on Corrales Road. Across the street is Hoffhein's Garage, located in the former Society Hall. Grapevines are planted in the Perea front yard, and Frankie remembers picking them for his great-grandfather to make wine. Later in life, Frankie served on a nuclear submarine for five years in the 1960s. (Frank Perea.)

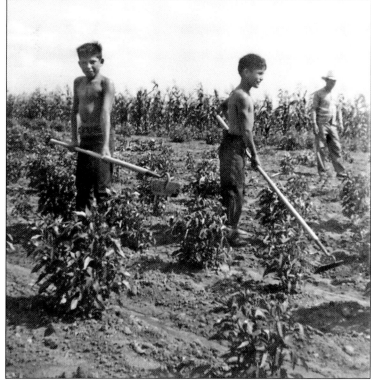

Tony Jr. (left) and Louie Cordova join their father Tony Cordova (far right) in hoeing the chile patch in mid-summer in the mid-1950s. Their father worked in construction during the day, so the children had to be sure to finish their farm chores before he returned home. (Jackie Cordova Barajas.)

In the early 1950s, the Cordova family bought a Guernsey calf from Thatchers Dairy on Edith Boulevard in Albuquerque's north valley. They did not have a mother cow, so a goat provided milk for the calf. Standing proudly with their new purchase are Tony and Adelina Perea Cordova with their children (from left to right) Jackie, Mike, and Louie. (Jackie Cordova Barajas.)

Horses were an essential part of farming, and nearly all the children raised on Corrales farms could ride. Younger family members had to ride herd on the family cows to keep them out of the unfenced corn and alfalfa fields. In this early 1930s photograph, Roberto Griego (left) and his cousin Eloy Melendres pose astride BVD, who could also do tricks. (Neita Griego Gutiérrez.)

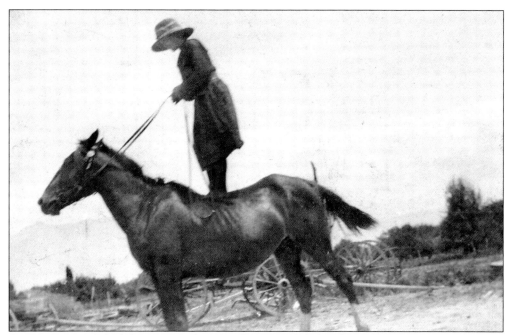

Becoming an adult did not mean leaving the animals behind. In this undated photograph, Roberta Alary stands on the back of her horse, perhaps a plow horse, near the old family home around the sand hills. Both she and Ida Salce were known for their horsemanship. (Rosie Targhetta Armijo.)

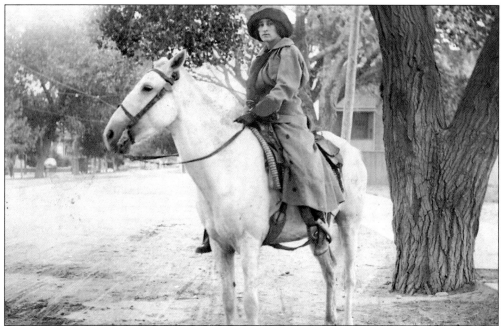

Altagracia Martinez eyes the camera from the back of her horse. This c. 1914 photograph was created as a postcard on which is written "Sandoval NM," but Martinez often visited friends in town, and this may have been taken in Albuquerque. Her outfit appears to have been the height of riding apparel style, including the split riding skirt. (Linda Gonzales.)

Through the years, the family car, truck, or tractor became a common element in family photographs. In 1934, Randolph Armijo's father snapped this photograph of his wife and children (with ice cream cones) by their 1927 Model T truck. From left to right are Pauline Vernier Armijo, baby Margaret Armijo, Ernestine Ruth Armijo in the bonnet, Marie Armijo, and Randolph Armijo. Randolph Armijo recalled that his father's mutt named Chico would run and jump on the running board. (Randolph Armijo.)

In this undated photograph, Jimmy Gutiérrez sits proudly on a tractor on a 1949 Chevy truck with his father, Marcos, (left) and Frank Johnson. Johnson's real name was Francisco Montoya, but he took the name of a boxer who was well known at the time. (CHS Archives.)

There were no swimming pools in Corrales until after World War II, so children and adults used the ditches to cool off. In the photograph at right, this is probably Celia and Anita Targhetta standing on a bridge over the Riverside Drain—or clear ditch—sometime in the 1920s. This was called "the cold ditch" since it carried groundwater from the river. To warm up, swimmers would move over to the adjacent irrigation ditch, which thereby earned the name of "the warm ditch." The clear ditch was also home to carp and trout for fishing expeditions. It continued to provide recreational delight throughout the years, as can be seen in this 1960s photograph below of Heidi Findley, Poppy Ballantine, Doug Findley, and an unidentified boy on a boating expedition. (Right, Rosie Targhetta Armijo; below, Pete Smith.)

The second swimming pool in the village was built in 1958 by Pete Smith and Randolph Armijo, with muscle power provided by Smith's horse Ebony. The neighborhood kids used the pool and were often invited to lunch by Smith's wife, Pat, who also taught them how to swim. In this 1967 photograph, Pat Smith's children by her first marriage, George and Poppy Ballantine, enjoy the water. (Pete Smith.)

For many years, 10 or so acres just northwest of the village were covered by high sand dunes—a true desert playground. Some of the older boys would ride their horses there and play *cholla*: two teams trying to rope a wooden "star" and pull it across a goal line. Photographer Dick Kent took this image of his children in 1962 crossing the dunes as the sun set. (Kent Family.)

Seven

MOVING ON

The world-changing events and ever-increasing pace of technological inventions of the 20th century confronted young Corraleños with a myriad of choices. People born in the early years of the 20th century were more likely to continue farming. But in the Depression years, Corrales farmers found it a struggle to make ends meet. Many children—and parents—left Corrales, sometimes to study and make a living elsewhere, but more frequently to find work. This was especially so during World War II, when work was plentiful in the California defense plants. Some would eventually return to the family farm to contribute their earnings and their labor.

Many of the men joined the armed forces. Their wives or sweethearts stayed behind to run the farms or looked for work in burgeoning Albuquerque. Children who grew up during World War II entered a working world of wide possibilities thanks to the technological progress catalyzed by the war effort and the booming Albuquerque economy after World War II.

Even with the demands of farm work and earning a living, adults found time to enjoy the world of their childhood. The pleasures of a small rural community lasted well into the 1950s, and some would say still enliven Corrales. Horses were gradually replaced by the motorcar, and having any car at all was a reason for taking its photograph. Hunting and fishing was always a diversion for some and was a necessity during the Depression, when venison appeared on dinner tables. The ditches attracted swimmers of all ages in the long hot summers.

The men from Corrales who served in the armed forces saw the wider world, usually for the first time. Some never came back, and their gravestones dot the old cemetery at the San Ysidro mission church as well as the National Cemetery in Santa Fe. For those who returned, the Corrales they found was beginning to change, but friends and family remained constant.

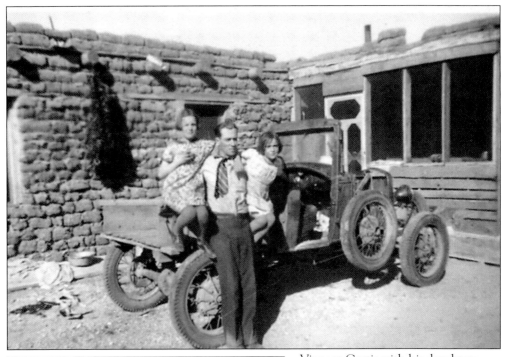

Vincent Curtis with his daughters Dorothy (left) and Evelyn lean on the truck he put together from "junk" that he collected from all over the village during the Depression. Their house was built of both adobe bricks and *terrones*. (Evelyn Curtis Losack.)

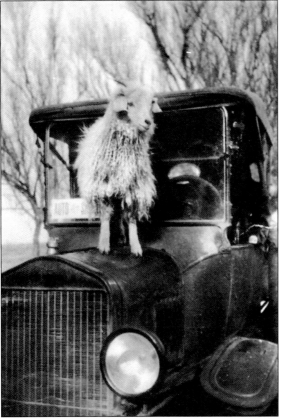

Battista Targhetta's first car, a Ford Model T, provided a convenient perch for a goat (they love to climb), and someone snapped this photograph in the mid-1920s. Battista's children well remember their parents' story that this car got a flat tire on his first date with Roberta Alary. (Rosie Targhetta Armijo.)

Cars remained essential to romantic relationships. From left to right, Emiliano ?, Frances Tafoya, and Lupe ?, chat by their Chevrolet in this photograph probably taken around 1955. Francis learned to drive on her own with her brother-in-law Horacio Martinez's car; he was the local lawman and his car even had a siren. (Frances Tafoya Trujillo.)

Seventeen-year-old Cliff Pedroncelli leans against his brother Jenaro's 1953 Buick in 1959. Jenaro Pedroncelli remembers that driving with "the big boys" to Santa Fe was like "a European tour." One got to ride in someone's car by chipping in money for gas, which was only about 15¢ a gallon. (Clifford Pedroncelli.)

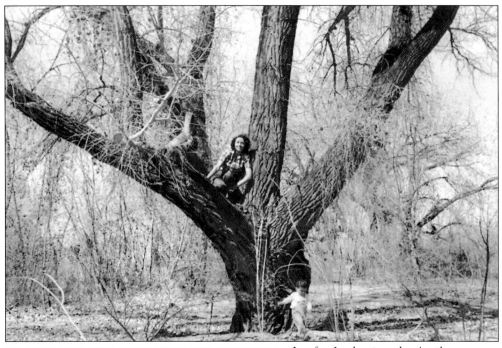

Josefita Leal enjoys the April sun in the bosque in this 1951 photograph. Her son Tino waits at the base of the large cottonwood in which she sits. In the 1950s, the Corrales bosque, now protected, was a beautiful place in which to play and picnic, as well as a place where cattle were grazed, wood was cut, cars were abandoned, and people dumped their trash. (Dianne Leal.)

Adjacent to the bosque is the "clear ditch," a drain dug deeper than the bed of the Rio Grande to take water from the river that would otherwise seep onto the farm fields. This 1920s photograph shows that its clear cold waters attracted adult swimmers as well as children. (Rosie Targhetta Armijo.)

Hunting was popular with many adults in Corrales. In this 1940s photograph, Vivian Chavez (left), Valentin Leal (center), and Virgil Salce display the results of their prowess as they return from hunting in the Jemez Mountains. Behind them is Leal's L and L Bar. (CHS Archives.)

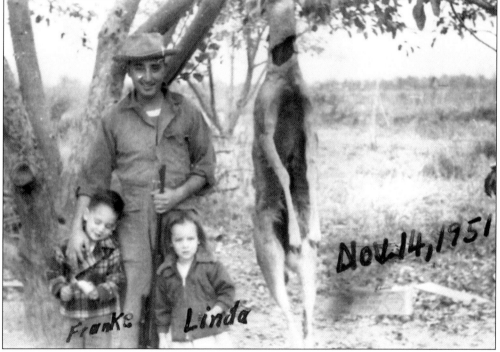

Nearly every year, Conrad Gonzales took time from his job as a water engineer to hunt, usually near his friend Cristino Griego's ranch near Cuba, New Mexico. When he was young, he learned how to hunt from Corrales neighbor Emile Alary. In November 1951, Gonzales, his son Frank, and daughter Linda pose next to the skinned carcass of a deer. (Linda Gonzales.)

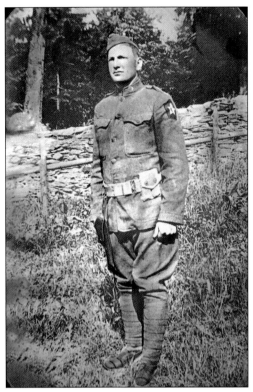

Entering the military was often an occasion for a photograph, and many of the pictures collected recorded a son or husband in uniform. This 1917 photograph is of Battista Targhetta, who joined the army with his brother Tony to qualify for U.S. citizenship. Both of them were born in Italy, so they fought against their native country. (Rosie Targhetta Armijo.)

Another soldier from Corrales was Esquipula Armijo, shown here on the left. His buddies are Apolinario Montaño with the mandolin, and a man with the surname Padilla on the right, both also from Corrales. Armijo and the others joined the armed services soon after World War I and served for four years. (Randolph Armijo.)

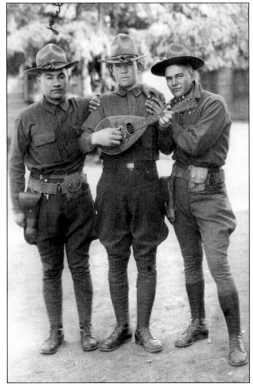

Felipe Lucero (center) poses at right in 1942 with his sisters-in-law Adelina Perea Cordova (left) and Erminda Perea Garcia. Lucero married their sister Margaret in 1939; he told her that he would mail her his watch if he were assigned overseas since he could not tell her where he was going. The watch arrived not long after the letter. Felipe had joined early and was at Pearl Harbor when it was attacked. (Ruby Lucero Montaño.)

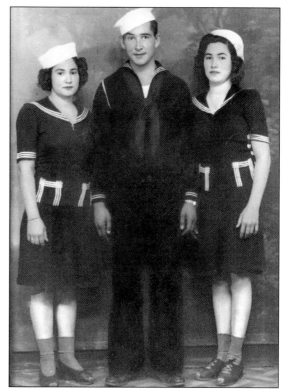

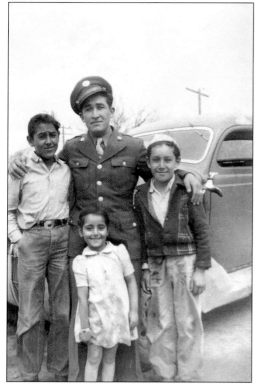

At left, Leo Leal poses with relatives in 1944 before returning to the European front. On the left is his brother Joe Leal, and in front of him is his niece Dianne Leal, the daughter of Leo's brother Valentin. On the right is a nephew, Diego Garcia, son of Leo and Valentin's sister Margaret. (Dianne Leal.)

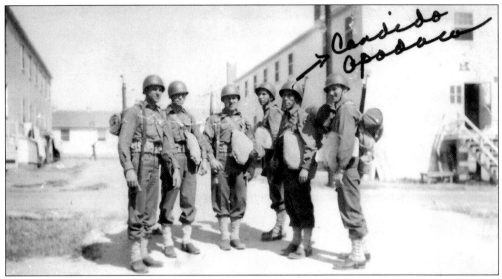

Candido Apodaca (second from right) wrote home to his family in 1942 that this photograph was taken after he returned from inspection with a full pack. He asked his mother to keep the picture since "these are good friends of mine and I want this for remembrance." Apodaca served all over the Pacific; he was a patriotic man and named his animals for army ranks. (Charlene Whiteman Davis.)

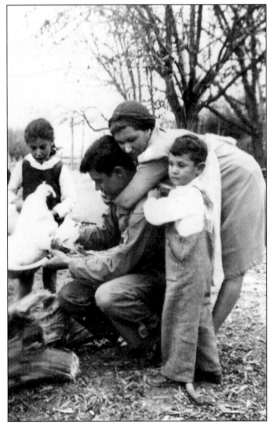

Cristino "Chris" Griego was the eldest son of Miguel and Cleofas Griego. He joined the army in 1940 and served for 21 years, but he never saw combat. In the c. 1944 photograph at left, Chris is draining blood from a beheaded chicken while at home on leave. His mother, Cleofas, hugs him; Mikey, the Griegos' youngest son, hangs onto his shoulder. His sister Marianita Griego is at left. (Neita Griego Gutiérrez.)

Eight
AFTER THE WAR

Corrales was transformed by World War II. Returning servicemen and those who had gone to California to work brought back new perspectives on life in Corrales, and newcomers brought new ideas and new energy.

Albuquerque boomed after the war. Servicemen who were stationed there returned to live in the "Land of Enchantment," and some arrived to study at the University of New Mexico, which was gaining a national reputation for its archeology and art programs. A few of these students found Corrales, where the single nod to progress was paving the old road leading north from the narrow, metal truss bridge. The other village roads remained narrow dirt tracks that were muddy after a rain and dusty most of the time.

The first of the mid-20th-century newcomers did not care if the village was hard to reach; in fact they liked it that way, even though there were few or no public services. Far from the booming city, Corrales offered a beautiful pastoral landscape, the freedom to live an independent life, and land that cost less than $500 an acre.

University professors discovered Corrales early and were soon followed by other professionals and artists. Some came to try their hand at farming, while others planted an orchard or a vegetable garden, but these were usually secondary to their creative or professional work. By 1952, old and new residents had organized a community council, and the council soon created a volunteer fire department. Efforts to create a library culminated with the building of a small structure that housed both the library and the fire department in 1957.

Efforts to incorporate Corrales began early in the 1960s and came to fruition in May 1971, when residents in the center of Corrales voted in favor of incorporation. Other sections of Corrales were incorporated into the village during the next 18 years. Corrales' present boundaries were finally established in 1989.

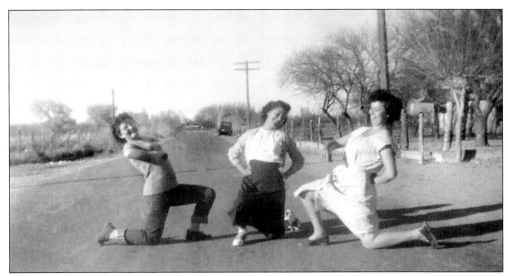

Corrales Road was paved just after World War II all the way to the ranch at the north end of the village. Perhaps to celebrate the paving, three Corrales girls—Rosie Targhetta (left), Ernestine Armijo (center), and Priscilla Montoya—kneel exuberantly for the camera on the paved surface in the late 1940s in front of the Montoya home. (Rosie Targhetta Armijo.)

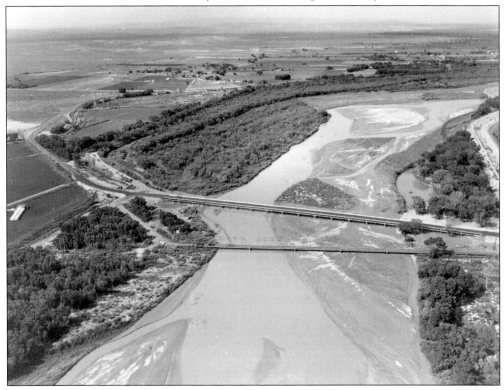

In 1957, a new bridge was built across the Rio Grande, replacing the old 1912 steel truss bridge. In this 1959 aerial view, taken by Dick Kent, the old bridge is seen just below the new bridge. For many years, the pylons that supported the 1912 span were visible when the river was low, which was most of the time. (Kent family.)

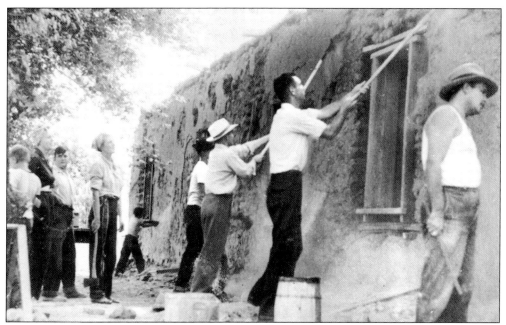

Corrales was "discovered" by Anglo families as a beautiful place to live, but not necessarily to farm, during World War II. Two families who bought property in Corrales at this time were the Harringtons and Owenses. These two photographs are of the Harringtons' old adobe, which they called Casa Vieja. In later years, it became a well-known restaurant. In the 1942 photograph above, Dorothy Harrington (standing third from left) and others are restoring the building. Dorothy Harrington's mother, Cora Headington, loved Corrales and wrote a colorful history of the village. The photograph below shows the restored building in 1943. From left to right are Ambrose Gonzales, Benny Garcia, Jim Harrington, Jone Harrington, "Lally" Contreras Perea, Bennie Gonzales, Cecilia Gonzales, and Mable Perea. (Above, CHS Archives; below, Frank Perea.)

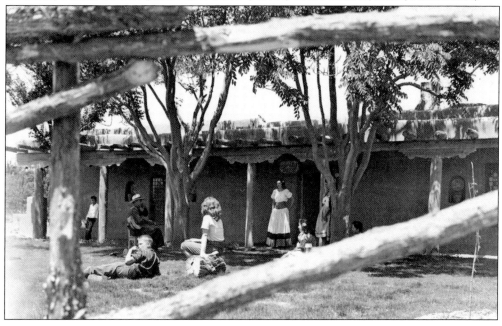

Alan and Shirley Jolly Minge came to Corrales in 1952 and restored an 1870s four-room adobe across from the old church. They then added eight more rooms to create a 19th-century Spanish *rancho* to hold their comprehensive collection of early New Mexican artifacts and architectural elements. Above is a 1981 view, taken by Betsy Swanson, of one of the restored original rooms; the *jergas* (handwoven floor coverings) are part of a collection unmatched in any other museum. The 1967 photograph at left shows (from left to right) Martin Minge, Charles Mullen, and Alan Minge standing in front of the west entrance to the central *plazuela* (patio). The home, now open for tours, became part of the Albuquerque Museum in 1997. (Above, New Mexico Historic Preservation Office; left, gift of Ward Alan Minge; Albuquerque Museum History Research Library.)

Donaciano Pedroncelli and Consuelo Martinez (pictured in 1943) came to Corrales from Los Griegos five years after their marriage. They lived and worked on the Trosello farm and eventually moving to their own place in 1951. Pedroncelli joined the army, and Consuelo ran the farm and raised Jenaro, Robert, Mary Frances, and Clifford. Clifford remained in Corrales and was elected to the first village council. (Pedroncelli family.)

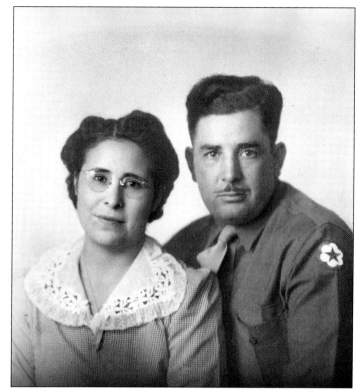

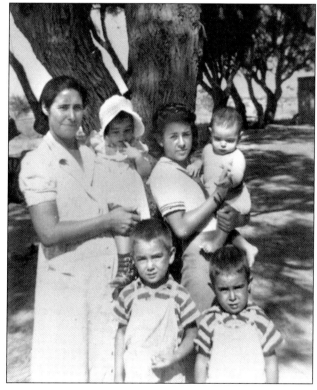

The Pedroncellis were photographed on the Trosello farm in 1942, the year they came to Corrales. Pictured from left to right are (first row) Jenaro and Bobby; (second row) Consuelo Martinez Pedroncelli holding Mary Frances, and Floripa (Donaciano Pedroncelli's sister) holding Clifford. (Clifford Pedroncelli.)

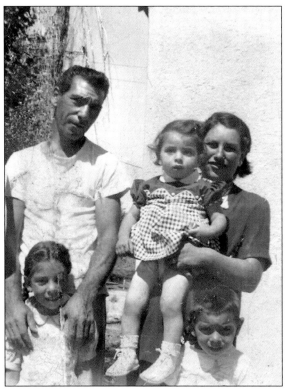

Tom Tafoya bought land in Corrales in 1938, but he and his family did not move to Corrales until 1946, when he married Irene Valdez from Mora and decided to start farming in Corrales. He was also the Corrales ditch rider for 18 years. In this c. 1954 picture are Tafoya with daughter Dolores, Irene Valdez Tafoya with Diana, and Tony Tafoya in front. (Tafoya family.)

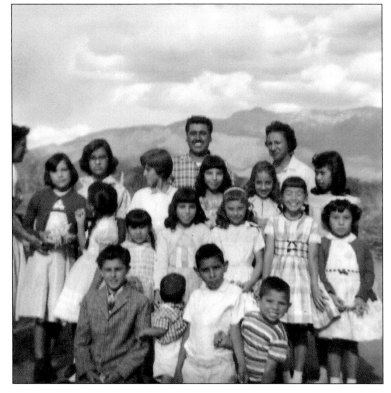

The Tafoyas celebrated their daughter Dolores's birthday with friends and neighbors in 1961. From left to right are (first row) Robert Gonzales, Joseph, Tony, and Mark Tafoya; (second row) Gloria Tafoya, unidentified, Diana Tafoya, Colleen ?, Margaret Garcia, and Cathy Gonzales; (third row) Irene Tafoya, Jeanna Maestas, Sue Maestas, Edena Spear, Dolores Tafoya, Ruth Weaver, and Pauline Espinosa; (fourth row) Joseph and Libby Espinosa. (Tafoya family.)

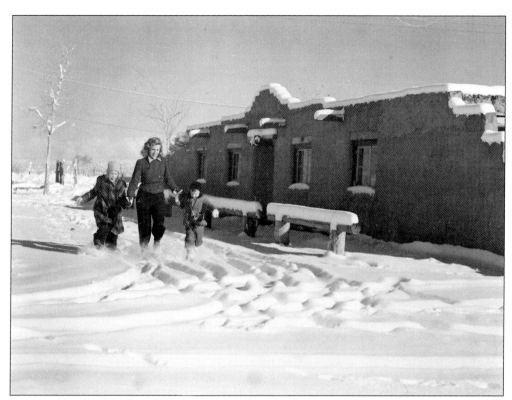

Cinematographer Ken Marthey moved to New Mexico for his health after World War II and settled in Corrales in 1947, where he built an adobe house. The above 1949 photograph shows his wife, Maggie, and children Kurt and Susan in a late spring snowstorm at the completed house. At right is a set of puppets made by Maggie Marthey for a show about San Ysidro. Through Harvey Caplin, Marthey became involved in making a documentary about Hispanic life in New Mexico titled *And Now Miguel*. The film won the first Robert Flaherty Prize for outstanding documentary films, and its success led to job offers in New York, where he worked for 20 years with major advertising firms. In 1971, he returned to New Mexico. (Photographs by Ken Marthey; Ken Marthey.)

During World War II, Harvey Caplin served as a U.S. Army Air Corps photographer in Albuquerque and fell in love with New Mexico. After the war, he and his wife, Grace, bought a house in south Corrales. His freelance photography business was so successful and his photographs of the Southwest were so popular that *New Mexico Magazine* named him "New Mexico's Million Dollar Outdoor Salesman." (Harvey Caplin estate.)

Dick Kent, pictured at right in 1980, and Ken Marthey had served together in Europe. In 1950, Marthey invited Kent to work on the film *And Now Miguel*, and Kent and his wife, Edie, came to Corrales and soon built an adobe home. A major commercial photographer, Kent won many prizes during his career and was named a master photographer by the Professional Photographers of America, Inc., in 1964. (Kent family.)

Artist Paul Wright, pictured above in this 1956 Dick Kent photograph, studied at the University of New Mexico after getting out of the navy. In 1948, he and his wife, Maureen, bought land in Corrales from Ruth Owens and, in the 1950s, built a home there. Wright taught art locally and helped start the Corrales Art Association. He was a muralist, sculptor, and painter. (Wright family.)

Internationally known painter and printmaker Adja Yunkers moved to New Mexico in 1950. He bought land in Corrales, built an adobe house, and planned to start an art school, possibly in Corrales. The effort failed, and Yunkers remained in Corrales only two years. The picture at right shows Yunkers and his wife, Kirsten, who stayed in Corrales, in the doorway of the adobe in 1951. (Sara Smith.)

The Corrales Art Association, founded in 1957, first exhibited at the La Sala Gallery, which is shown above in a photograph by Dick Kent. Artist and sculptor Pat Smith, who moved to Corrales in 1954, stands second from right. Smith, an accomplished artist who trained at the Arts Students League in New York, was instrumental in founding the Corrales Art Association and two local art galleries. In 1955, she married Pete Smith, who had arrived in Corrales in 1950 with a prospective teacher at Adja Yunkers's art school. Shown at left at his tamale stand, built for a fund-raiser, Smith was a skilled builder. He also served as the first president of the Corrales Art Association, president of the 1955 community council, chair of the first planning and zoning commission, and was an essential volunteer in the old church renovation. (Above Kent family; left, Pete Smith.)

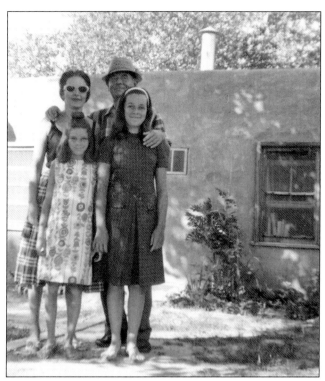

Betty Colbert, pictured around 1964 with her husband, Al Colbert, and daughters Annette (right) and Cecily, discovered Corrales during World War II while she was an art student at the University of New Mexico. After their 1947 marriage, the Colberts bought land in Corrales and built an adobe house. Colbert created award-winning pots and stoneware hanging lights. The latter so impressed famed architect Frank Lloyd Wright that he ordered some for a house he was designing. (Colbert family.)

Writer, artist, and potter Bette Dickson Casteel and her husband, Bob, moved to Corrales in 1958 into a house she designed. She studied ceramics at the University of New Mexico, developed innovative pottery forms and glazes, and won many awards for her work. She authored a book on Albuquerque's Old Town, where she had owned a craft store in the 1940s, and later wrote a short mystery story titled *Dental Probe*. (Doug Casteel.)

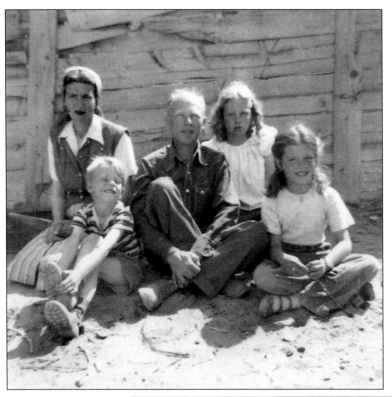

George Manierre (center); his wife, Gina (far left); and children, (from left to right) George V (GV for short), Molly, and Nora; sit for their photograph in 1950 when the family came to Corrales from Wisconsin to raise apples. Gina Manierre's sister, Casey, was married to anthropologist John Adair, and the Adairs lived in Corrales while he did research with the Navajos. (Nora Manierre Scherzinger.)

Daughter Margo Adair is shown at right outside the Adair home in the mid-1950s. On a 1949 visit to the Adairs, the Manierres fell in love with the village. The apple business did not succeed, so Manierre planted alfalfa and winter wheat, and also did carpentry and welding to earn a living. His children attended the elementary school, rode on the mesa, swam in the ditch, and helped with the farming when they could. (Clifford Pedroncelli.)

Corrales provided freedom for independent action. In 1971, solar pioneer Steve Baer built an experiment in design, materials, and energy conservation: a cluster of rhombic-dodecahedra made of a self-supporting structure of aluminum sandwich panels with an insulated honeycomb core and interior freestanding adobe walls. The south-facing walls (shown above) were made of 55-gallon barrels behind glazing to provide thermal mass to hold heat in winter and cool the house in summer. (Steve and Holly Baer.)

When the village needed a new library in 1978, volunteers dug foundations, laid adobe bricks, framed windows, scraped logs for the vigas, and then hoisted them in place as (from left to right) Cliff Pedroncelli, Sam Spitz, and Olin Schoaf are shown doing in this photograph. The new library opened in October 1979. (Corrales Community Library.)

In May 1971, Corrales residents voted to incorporate the village and soon elected a mayor, village council, and municipal judge. The newly elected village officers were photographed in September 1971. From left to right are Richard Perea, Horacio Martinez, Dulcelina Curtis, Mayor Barbara Tenorio Christianson, Clifford Pedroncelli, and Judge Elmore Browne. (Clifford Pedroncelli.)

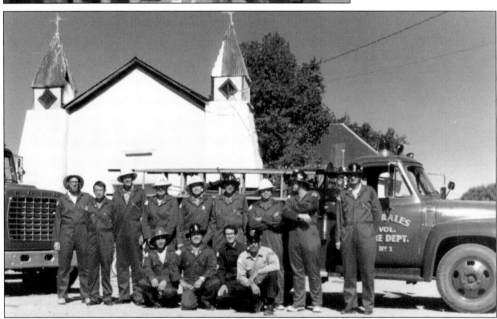

A volunteer fire department headed by Roger Silva, Emilio Lopez, and Justo Chavez had been formed in 1953 and was supported by an annual Fireman's Ball. At the 1974 San Ysidro fiesta, the much-expanded Corrales Volunteer Fire Department posed for this photograph by the old church. Emil LePlat stands at the far right, and in the first row, from left to right, are an unidentified firefighter, Julian Saiz, David Sanchez, and Alfredo Rodriguez. (Vickie Gutiérrez Saiz.)

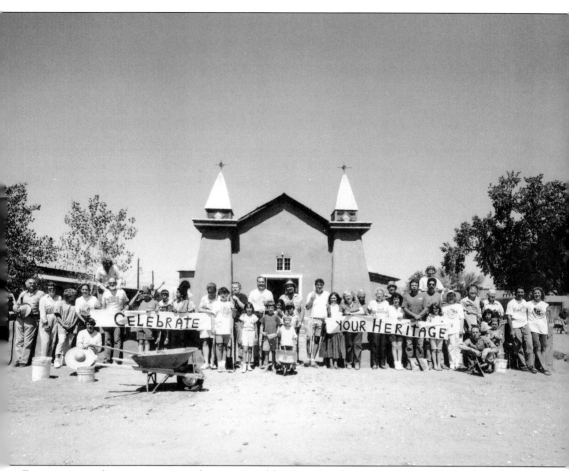

Every spring, volunteers come together on a "mudding" weekend to maintain the old church and its grounds. In 1991, this photograph of the volunteers, taken by John Wyckoff Jr., won the National Trust for Historic Preservation's "Celebrate Your Heritage" contest. From left to right are John Gary, Jeff Radford, Lyn Hagaman, Laura Stokes, Nicole Van Etten, Betty Blackwell (kneeling), Ben Blackwell, Evelyn Losack (on ladder), Rip Mills, Jane Phillips (waving), Jeffrey Bender, Marion Sklott-Myhre, Tim Hagaman, Claire Van Etten (with hoe), Bobbie Strickland, Danelle Callan, John Callan, Michael Pijoan, Jessica Skott-Myhre, Javier Pijoan (with wheelbarrow), David Skott-Myhre, Hans Skott-Myhre, John Catasca, Georgia Catasca, Elsie Kinkel, Ramon Moreno, Maria de la Luz Moreno, Johnnie Losack (in hat, behind), Lori Aldrich, Ross Howard, Laurie Phillips, Erin Phillips, Barbara Pijoan (behind, on ladder), Roberta King, Ed Boles (seated), Fred Hashimoto, Emily Hashimoto, Jeffrey Hashimoto, Jim Kinkel, Oliver Pijoan, and Janna Pijoan. Several workers in the photograph were relative newcomers to Corrales, but like the old-timers and the early postwar arrivals, they treasure the beauty, tradition, and unique spirit that make up their village. (CHS Archives.)

Discover Thousands of Local History Books Featuring Millions of Vintage Images

Arcadia Publishing, the leading local history publisher in the United States, is committed to making history accessible and meaningful through publishing books that celebrate and preserve the heritage of America's people and places.

Find more books like this at
www.arcadiapublishing.com

Search for your hometown history, your old stomping grounds, and even your favorite sports team.

Consistent with our mission to preserve history on a local level, this book was printed in South Carolina on American-made paper and manufactured entirely in the United States. Products carrying the accredited Forest Stewardship Council (FSC) label are printed on 100 percent FSC-certified paper.